MW00559267

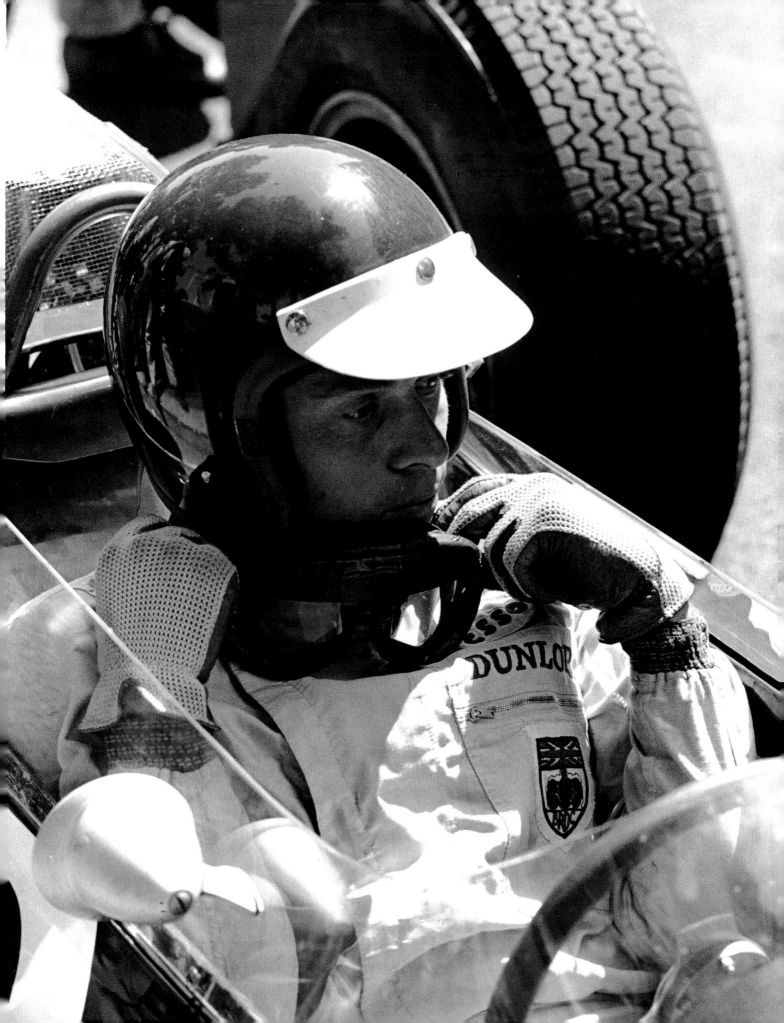

CHRONICLE BOOKS
SAN FRANCISCO

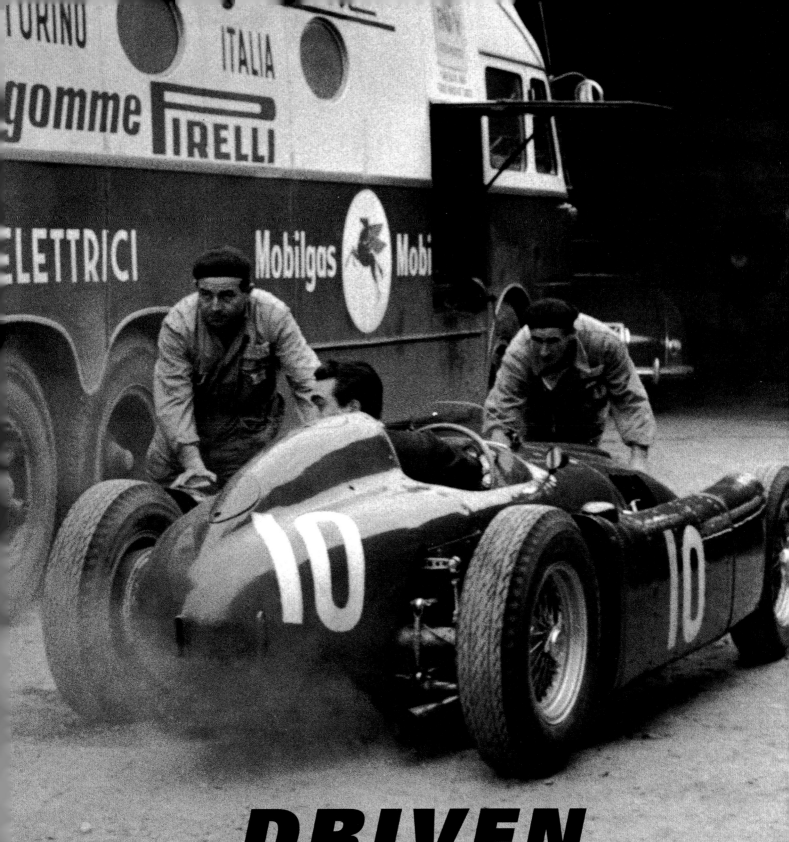

DRIVEN

THE RACING PHOTOGRAPHY OF JESSE ALEXANDER 1954–1962

introduction by **Stirling Moss** *photographs by* **Jesse Alexander**

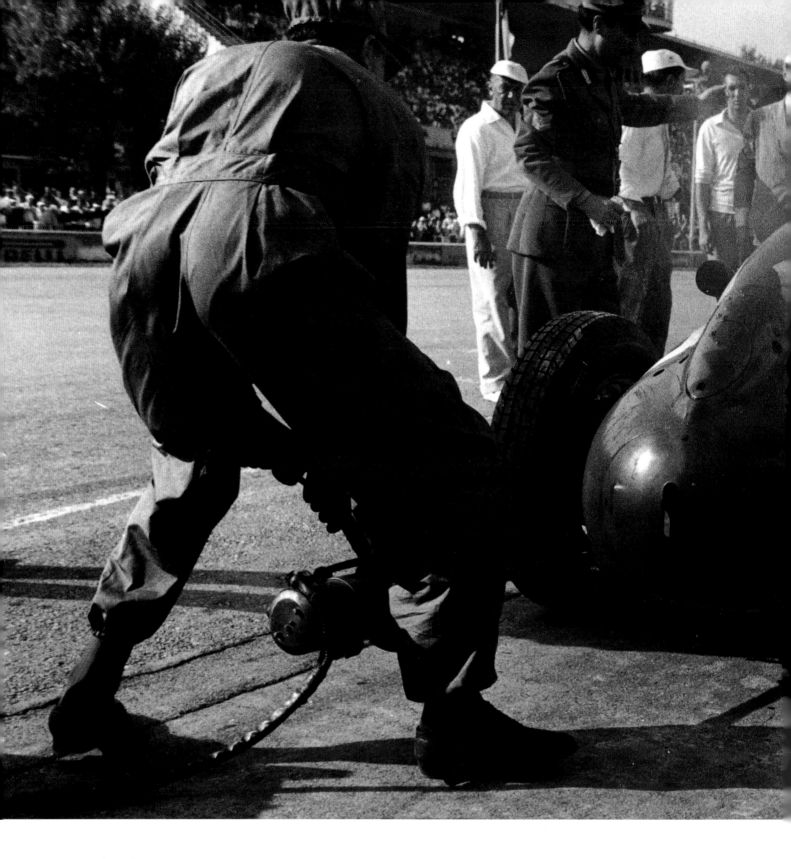

DEDICATION - - - - - *For Nancy*

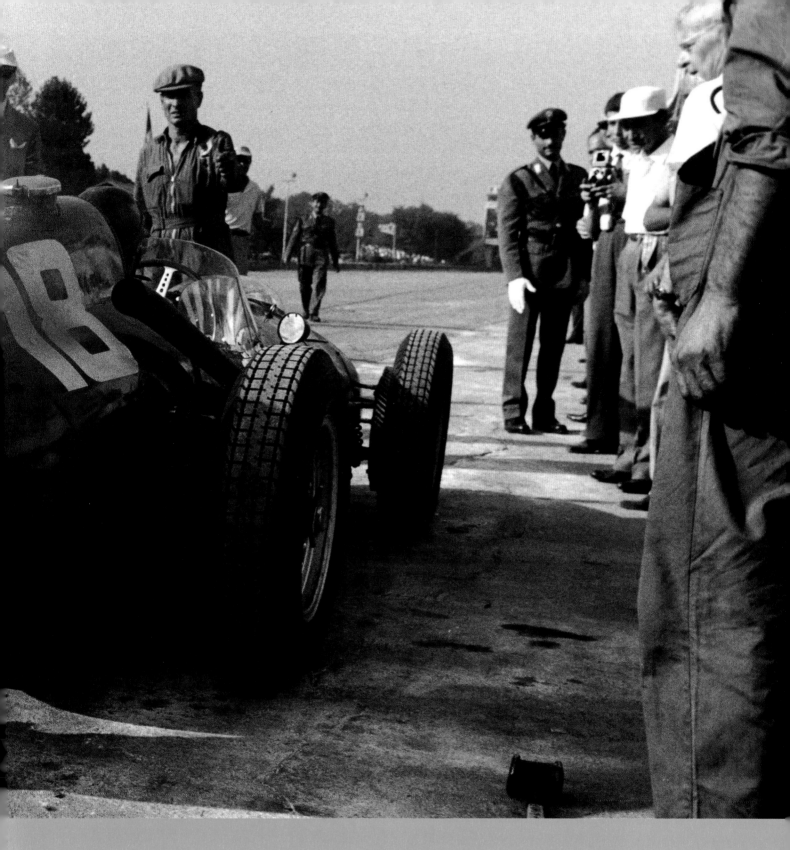

Copyright © 2000 by Jesse Alexander.

All rights reserved. No part of this book
may be reproduced in any form without
written permission from the publisher.

Library of Congress Cataloging-in-Publication
Data available.

ISBN 0-8118-2851-4

Design by Jeremy G. Stout
Composition by Suzanne Scott
Printed in Hong Kong

Distributed in Canada by
Raincoast Books
9050 Shaughnessy Street
Vancouver, British Columbia V6P 6E5

10 9 8 7 6 5 4 3 2 1

Chronicle Books LLC
85 Second Street
San Francisco, California 94105

www.chroniclebooks.com

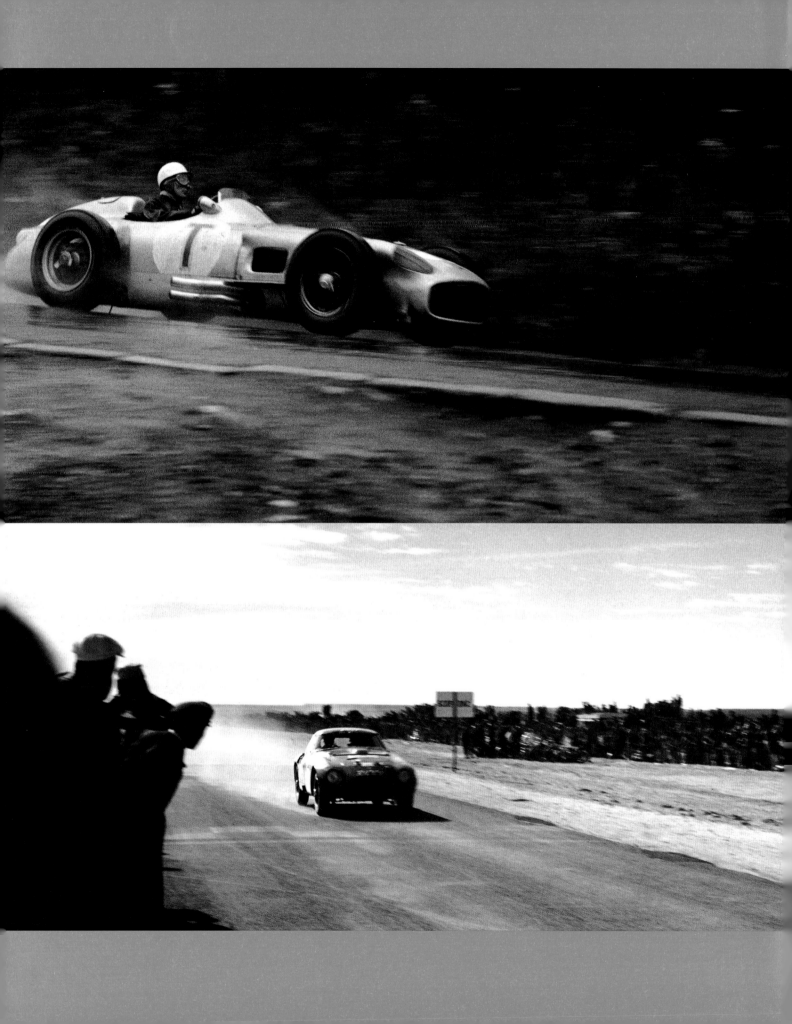

CONTENTS

TOP LEFT: PLATE **4** ----- BOTTOM LEFT: PLATE **5** ----- BELOW: PLATE **6**

IT'S A GREAT *PRIVILEGE TO BE ASKED BY JESSE ALEXANDER* TO PEN THIS INTRODUCTION TO HIS LATEST BOOK. THE DRIVERS AND PARTICIPANTS WHO WORKED WITH JESSE DURING HIS DECADE ON THE EUROPEAN CIRCUITS KNEW HIM NOT SIMPLY AS A HIGHLY REGARDED MOTOR RACING PHOTOGRAPHER BUT ALSO AS A REAL ENTHUSIAST AND A GENTLEMAN. HE UNDERSTOOD MOTOR RACING AND SHARED OUR PASSION FOR IT. THIS, AS MUCH AS HIS TALENT, MADE HIM "ONE OF US." FORTY YEARS AFTER THE EVENTS THAT ARE THE FOCUS OF THIS COLLECTION, JESSE ALEXANDER CONTINUES TO EXHIBIT THE SAME FINE EYE AND VIRTUOSITY THAT PRODUCED THESE STUNNING PHOTOGRAPHS.

INTRODUCTION

by Stirling Moss

Jesse began his career as a racing photographer in the early fifties. Among his first assignments was the 1953 Carrera Panamerica Mexico, the long and challenging Mexican road race. Hooked on the sport, he moved his family to Europe in 1954 to cover the great continental circuits. He would remain in Europe for nine years, eventually acting as the European editor for *Car and Driver* magazine. Immersed in racing, he spent nearly every weekend at an event and soon became a trusted and accepted member of the "circus," as the motor racing world was known.

In Europe, Jesse would witness and record the evolution of racing machines during the fifties; he would also chronicle a critical design revolution that began in the late fifties as mid-engined race cars began to dominate the tracks. At the beginning of the decade, racing automobiles pretty much embodied pre-war theories. The drivers sat upright behind the engine in a long, streamlined body that was supported by a separate chassis and frame. Drum brakes and wire wheels were the norm. Over time, technical specifications improved, but the basic shape and configuration remained unchanged.

In 1958, the real revolution began in earnest. It had started with Cooper in 1955 and continued as British designers placed the engine behind the driver, in front of the rear axle. Although mid-engined race cars had been campaigned by Auto Union in the 1930s, they had mixed results. Now, the car's designers began to master the intricacies of mid-engine placement. Smaller, lighter, better balanced, and more efficient than their front-engined competitors, mid-engined cars were winners from the late fifties. That design revolution continues to this day, with virtually all competitive race cars sharing this same basic configuration.

Racing in the years when Jesse was shooting these photographs was very different from motorsports of today. In those days, cars were always painted a national racing color: green for Great Britain; red, Italy; blue, France; white, Germany; blue and white, United States. Today, the cars are a rainbow of colors; they—and the drivers—are festooned with decals promoting their sponsoring companies.

Many of the old circuits offered little protection in the event of an accident, or shunt as it's called in the racing world. The courses often ran through villages, across bridges, and beside rivers or large trees. There was little margin for error. Today's circuits are purposebuilt, with sand traps and tire barriers to catch spinning cars.

Jesse's photos also starkly reveal the slow pace of development in driver protection. Throughout this decade, the systems for ensuring driver safety—on the track and in the cars—evolved with much less rapidity than changes to the cars themselves. Look at the photographs: Not until the sixties would drivers forego the thin polo helmets with their leather ear flaps and the polo shirts or lightweight driving suits for more substantial protective gear.

Yet, it was a magical time. Ten years on, Europe was emerging from the dreary war years and was being rebuilt. By the middle years of the fifties, Ferrari, Mercedes-Benz, Maserati, Jaguar, Aston Martin, Porsche, and a host of other constructors competed all over the continent in a dizzying variety of racing events. Spectator interest soared, and, as economies improved in each country, racing more and more became a way to promote the sale of production automobiles.

Immediately prior to World War II, the world of auto racing had witnessed a golden decade, a time of rapid technological innovation and wonderfully

talented drivers who waged epic battles in cars built by constructors such as Mercedes-Benz, Auto Union, Alfa Romeo, and Maserati. Racing for national prestige, these companies often received direct financial support from their governments. The war interrupted the racing but did not destroy the competitive urge to build exotic cars and to drive them faster than anyone else.

World War II ended in Europe in May 1945; in September, in Paris, the first post-war race was held. The Grand Prix des Prisonniers simultaneously recalled the past—pre-war autos made up most of the grid, and the race was also a tribute to those individuals killed in the conflict—and looked forward to new competition among countries that had recently been bitter enemies. With the end of the war, people looked forward to the pleasures of peace—and to the thrill of auto racing. I was among them.

A young boy at the time, I was just discovering the world of motor racing with the support of my father. By 1949, I began racing internationally when we purchased a little Cooper. Tiny and primitive, the open-wheeled racer was ideally suited to racing in countries that still suffered from a shortage of many goods. It accommodated either a two-cylinder, 1,000cc, air-cooled engine or a 500cc, single-cylinder unit. This arrangement allowed enthusiasts to contest either 2-litre Formula Two events using the larger engine, or 500cc Formula Three races with the smaller unit bolted into place. The Coopers introduced affordable motor racing to Britain; by the end of the decade, the country was quite wild over the sport.

In 1949, I entered a Formula Two race at Lake Garda, in northern Italy. It was a fantastic experience. I was only nineteen, and this was my debut in a proper continental public road circuit, rising and falling through the hills, running through villages; it was demanding and difficult and absolutely brilliant! In the "big car" class were drivers I had only read about: Gigi Villoresi, Mario Tadini, and Count Bruno Sterzi, each with a big 2-litre V12 Ferrari. Their cars had enormous power and towered over me. It was accepted wisdom that the Brits couldn't build racing cars for toffee. When we'd first arrived, they regarded our Cooper as a complete joke and christened it the "jukebox." But the Cooper was nimble and handled well. In practice I set third fastest time overall—quicker than Tadini—then finished third in the final and won my class. The Italian crowd simply went bananas.

It was to be a formative experience. I won the equivalent of several hundred dollars, which seemed a fortune. I began to appreciate that racing could pay, that there was a living to be earned. As for racing

itself, I was simply enthralled and absorbed by it. I found it fantastically exciting. I was seeing the world at a time long before the package tour had become popular. Driving from one circuit to another around still-war-shattered Europe could be time consuming, but it was fascinating.

In 1950, Alfa Romeo dominated the newly organized World Championship series. Ferraris, Maseratis, Talbots, and Simca-Gordinis also competed in the six championship events. During the year, two truly wonderful characters, George Abecassis and John Heath, gave me my first big break. They ran Hersham & Walton Motors in Walton-on-Thames, just southwest of London. Tremendous racing enthusiasts, they signed me to drive their new HWM team cars, beginning my career as a professional racing driver.

George and John were both experienced, intelligent men. George had been a Royal Air Force pilot in the war, decorated for flying agents into Europe. He was a real press-on driver in his own right who went on to build a long career with Aston Martin. Once, when team chief John Wyer rebuked him for writing-off a works car, George complained: "When I shunt a car, you give me a terrific bollicking. When I shunted my bomber, the RAF gave me the bloody Distinguished Flying Cross!"

Racing the HWMs on those wonderful circuits made 1950 a master's course in race driving. I raced against Juan Fangio for the first time. Fangio, who

PLATE **7**

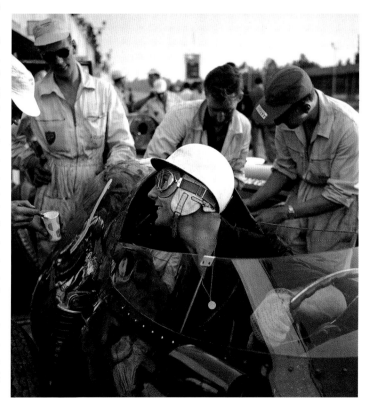

was to be a five-time World Driver Champion, had a sense of humor and an instantly attractive personality. I came to think the world of him—and eventually to be his teammate with Mercedes-Benz in 1955.

In 1951, the world racing organizers announced a new formula for the World Championship, to be put into effect in 1954. Engines would be limited to 2500cc unsupercharged, 750cc, supercharged. In the intervening years of 1952 and 1953, Formula Two rules for 2000cc engines would govern the races. In 1952, I was given the chance to drive the new, all-British BRM V16. This British effort appealed to me, since I am naturally patriotic. Not since the days of Sunbeam and Sir Henry Segrave in the 1920s had Britain fielded a Grand Prix car capable of winning races. I was desperately keen to do well in a British car. But the BRM proved an awful disappointment. With its sixteen cylinders, it produced a sublime exhaust howl, but it was horribly unreliable, and very difficult to drive.

During these years, British drivers were beginning to be a force in Grand Prix racing. Ferrari, Vanwall, and others courted Mike Hawthorn and Peter Collins, and me. We were young men, having a whale of a time. Many of us traveled together. We socialized, whether teammates or rivals. While Mike Hawthorn and I might be dicing wheel-to-wheel one weekend in a Grand Prix, the following weekend we could be teammates, throwing our rally cars around the Alps. We raced often. A driver had to race in all types of cars, from open-wheeled formula machines to saloons. Today, you often find a definite separation among drivers who specialize in a particular facet of the sport. In the 1950s, one needed to be versatile, if only to maximize one's income.

The new 1954 formula renewed the interest of the pre-war juggernaut, Mercedes-Benz. My father and manager approached Alfred Neubauer, Mercedes' legendary racing director, about a ride. He informed me that whatever talent I might have was being obscured by driving inadequate cars. If I proved myself in a competitive Grand Prix machine, he might reconsider. The reaction of my father and my manager, Ken Gregory, to Neubauer's comments might surprise today's fans: The two ordered me a new Maserati 250F. That was possible in the fifties. I doubt a privateer today could buy a competitive Formula One machine from the factory, even assuming the funds were available.

The gamble paid off. After I practiced well at the Nürburgring, I was offered a place on the Maserati team. At the Swiss Grand Prix on the very difficult and fast Bremgarten forest circuit, I set fastest time in wet practice, ahead of every Mercedes-Benz, Ferrari, and Maserati. Neubauer was impressed, and by the end of 1954 I signed with Mercedes to drive Formula One and sports cars in 1955. I was also free to drive for other manufacturers, provided the commitment did not clash with my Mercedes contract. That was a stellar year for auto racing and for me,

Among my fondest memories is the win I shared with Denis Jenkinson at the 1955 Mille Miglia in Italy. Denis was my navigator in the Mercedes-Benz 300SLR sports car. He was an extraordinary man, correspondent for *MOTORSPORT* magazine, former motorcycle racer, and 1949 World Champion sidecar racing passenger in partnership with the great Eric Oliver.

Building upon a suggestion of American driver John Fitch, Jenks logged landmarks all round the course on fifteen feet and six inches of roller paper. Between us, we perfected a hand-signal system, so he could keep me informed, regardless of the noise, of hazards round the next blind corner or brow. Obviously, we had no way to note every corner over 1,000 miles of circuit. During the painstaking reconnaissance, we selected hazards that might kill us as opposed to those that might merely cost us time if we slowed too much for them.

From the outset, we believed we might finish third, behind Mille Miglia expert Taruffi, and Kling or Fangio. Mercedes' idea was to shut out Ferrari. During the race, I slowly gained confidence in Jenks' signals. At one point, we were caught and passed by Castellotti's fantastically powerful 4.4-litre Ferrari, which we watched leaving rubber burned onto the road as it accelerated away from us above 150 mph. But he didn't last.

In Rome, we were handed a note listing the leaders: "Moss, Taruffi, Herrmann, Kling, Fangio." We were shocked to be in the lead. I really didn't want to hear it, as I'm superstitious and believed the great Mille Miglia truism that, "He who is first to Rome is never the first to reach home."

As we were climbing the Radicofani Pass, a front brake grabbed badly, and we spun tail first into a ditch. Fortunately, we were able to press on, through Florence and up to the Futa Pass, which was slippery, toward Bologna. We rocketed into Bologna at 150 mph, had our card stamped, and were off again before anyone could tell us our position. Then we were thundering into the finish at Brescia, past Jenks' last pace note. He

let the notes sag onto his lap. As I turned into the finishing straight at 100 mph, we both began waving for all we were worth—rather un-English, actually.

We finished and knew we'd done well. I asked Jenks, "Do you think we've won?" as we edged the crumpled Merc toward the finishers' paddock. When the news of our first-place reached us, we were mad with joy. The whole experience had been incredibly satisfying. We had averaged nearly 98 mph for 1,000 miles. Odd to appreciate now that in one day we covered the distance of six modern Formula One events.

During 1955, I also won my first Grand Prix—my home race in Britain—by inches from Juan Fangio. I don't know for sure to this day whether he let me win because he felt that I'd worked hard enough to deserve it, or whether I beat him fair and square. Juan was a truly sporting gentleman, but competition between us was acute and genuine. He never did tell me whether he was really trying that day at Aintree—nor did I ask.

I continued that year for Mercedes, until they withdrew from racing following a horrific accident at Le Mans that killed many spectators. In need of a ride, I finally returned to Maserati, and I won my second Grand Prix at one of my favorite venues, Monaco, where the crowd is so close you really feel like a performer on a stage.

In our second Mille Miglia, in 1956, Jenks and I shared an ill-handling sports Maserati 350S. In driving rain, I finally lost it when the brakes locked. We had an almighty shunt, vaulting off a bank, crashing through a concrete roadside barrier, and launching ourselves down a mountainside. In our flight, we burst through a barbed wire fence that gouged the car's windscreen, my goggles, and wristwatch glass, yet left only the merest nick beneath my right eye. Jenks was unscathed.

We waved as Luigi Musso and then Cesare Perdisa drove by. Next we heard a big Ferrari thundering down towards us through the rain. It stopped! It was Fangio, bless him, checking on us. When we reminded him that there was a race on, he shrugged, blew a stream of water from his lips, and took off—to finish fourth.

I was able to drive another British car in 1957, when I was offered a Vanwall. Team owner Tony Vandervell was a rugged, no-nonsense bearing manufacturer, a considerable business tycoon, very wealthy and sometimes quite a difficult character. His Grand Prix cars were his personal hobby. If he felt like driving one up to a circuit on race morning, he'd do so. If the

team driver then found the clutch burned out, that would be the driver's problem. He struck a distinctive figure at races, with his lightweight jacket, big Panama hat, and braces supporting his trousers.

Vandervell was never interested in non-Championship races. Whenever I had no Vanwall commitments, I drove private-owner Rob Walker's Formula One Cooper-Climax cars. Vanwall passed up the Argentine Grand Prix opening the 1958 season, so Rob sent down his hybrid 2-litre Cooper-Climax for me to drive. Rob and I never had a written contract. We were, and are, great friends, so we went ahead as friends.

Our effort in 1958 seems extraordinary today when Formula One teams fly tons of spare parts and scores of personnel to each race. Our team that weekend in Buenos Aires consisted of my first wife Katy, Alf Francis (Rob's chief mechanic), his assistant (quiet Australian Timmy Wall), and me. We were three blokes and a girl—and we won, with Alf brandishing a spare wheel and jack at me from in front of the pits to fool Ferrari into assuming I'd be coming into the pits. It was fantastic: the first contemporary Grand Prix victory for a mid-engined car.

By 1959, the mid-engine revolution really took effect in Formula One. Vanwall withdrew, and I elected to drive Rob's Coopers with the latest 2.5-litre Climax engines. We campaigned throughout 1959 and for two more seasons. Life became very hectic but very satisfying. Flying around the world midweek, racing every weekend had become my life. The 1961 season was typically frantic. It was one of my best and proved to be my last.

The Monaco Grand Prix opened the 1961 Championship series. Ferrari's new V6, mid-engine "sharknose" cars had at least twenty to thirty more horsepower than my 4-cylinder Climax engine in Rob's year-old Lotus 18. Driven by Phil Hill, "Taffy" von Trips, and Richie Ginther, the Ferraris were favored. I resolved that if they wanted to win, they'd have to fight for it. I might be in a year-old car with an inferior engine, but the car suited the tight circuit, and I would make them go.

I won the race by 1.2 seconds, after driving eighty-six of the 100 laps absolutely flat out. I strove for the perfect lap. I would judge myself on every lap, through every corner. If I made a mistake, I'd tell myself, "Right, the perfect lap starts here." If, for instance, the mistake had been at the Tabac corner on the seafront, then I'd try to eliminate any errors until

the Tabac next time around. If it was Gazometre or Station Hairpin where I made a mistake, I'd do the same thing on the next lap.

I believe the 1961 Monaco Grand Prix was my greatest drive. We won again at the German Grand Prix, my last Formula One win. In 1962, at Goodwood, a shunt in the Lotus-Climax V8 prototype left me in a coma for a month and paralyzed on my left side for six months. It ended my front-line career as a racing driver.

Those of us who raced at mid-century hardly recognize the cars of the new century. Composite alloys, computers, and telecommunications have transformed the racing automobile and the sport. It is a very serious business now, involving big money and the international reputations of countless firms.

It was, of course, more than simply fun. Much of the magic had to do with the people who were so passionate about motor racing. Jesse captures this human element of racing in his photographs. One of his great talents is this instinctive ability to reveal the role of both the machine and the human in automobile racing. You get the cars and the circuits, but you also glimpse the intense human emotions and effort involved. Jesse knows that racing includes engineers, team managers, mechanics, drivers, and supporting personnel. He has given us the entire world of motor racing in the fifties and early sixties.

As you go through these pages, pay particular attention to the captions (pages 121–139), which were written by Jesse. They provide detailed background

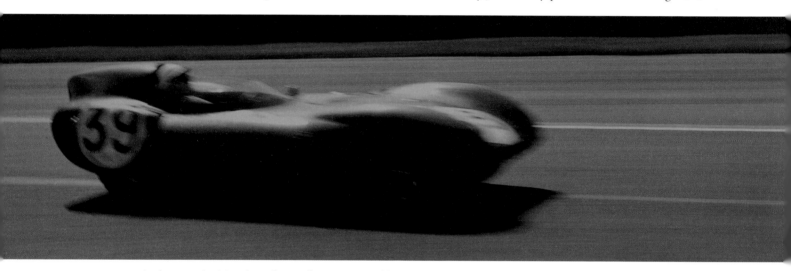

And now television broadcasts the races to millions of fans who would otherwise never have the chance to watch a favorite driver or car compete in distant parts of the world.

Recently, after an evening talk to the Friends of the National Motor Museum at Beaulieu in Hampshire, I was asked, "Do you think you would have as much fun if you were a Formula One driver today?" I had to think for a moment. Today's salaries are certainly enticing. But, if it were a straight choice between the money of today or racing in the fifteen-year period of my serious career, I have no doubt that I would forego the money and enjoy the fun we had in the fifties.

and information. In combination with his photos, they also convey the day-to-day life in racing. Jesse knew these people. He photographed them with care and interest, and he writes of them with an insider's sympathetic understanding of their triumphs and their failures. Here are the drivers, the mechanics, the spectators who loved motor racing and who made these such wonderful, magical years.

Stirling Moss

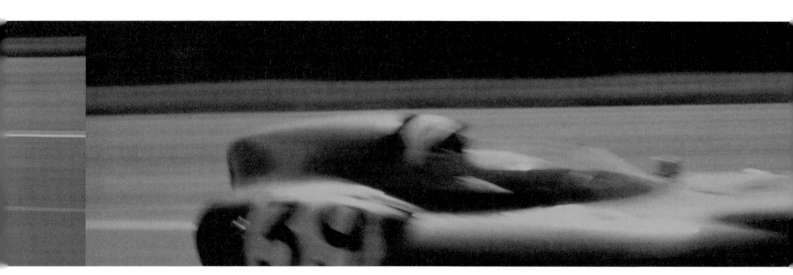

PLATES

→

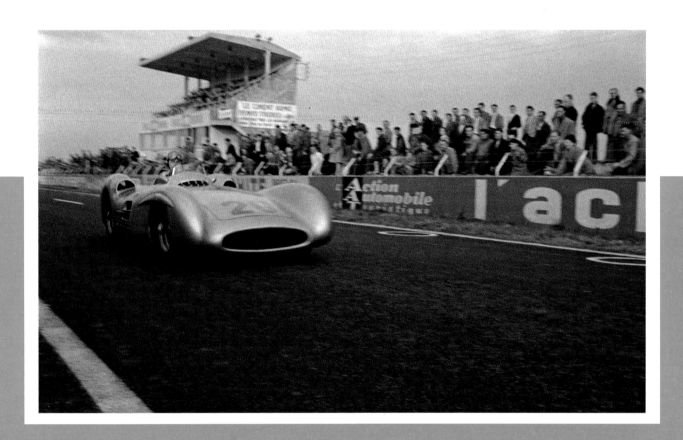

19
54

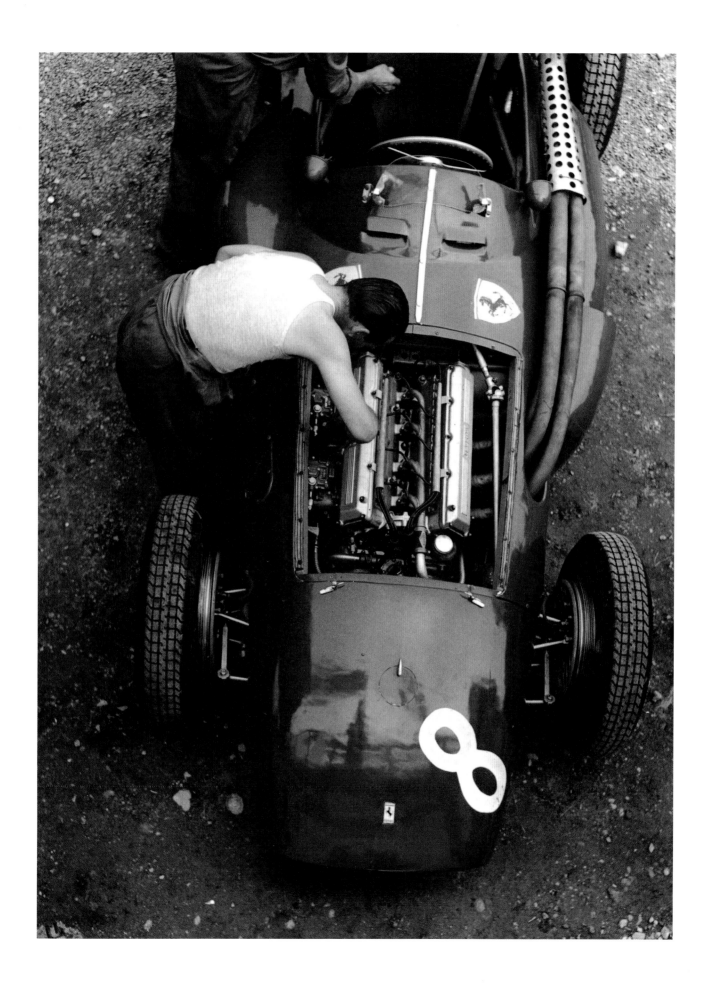

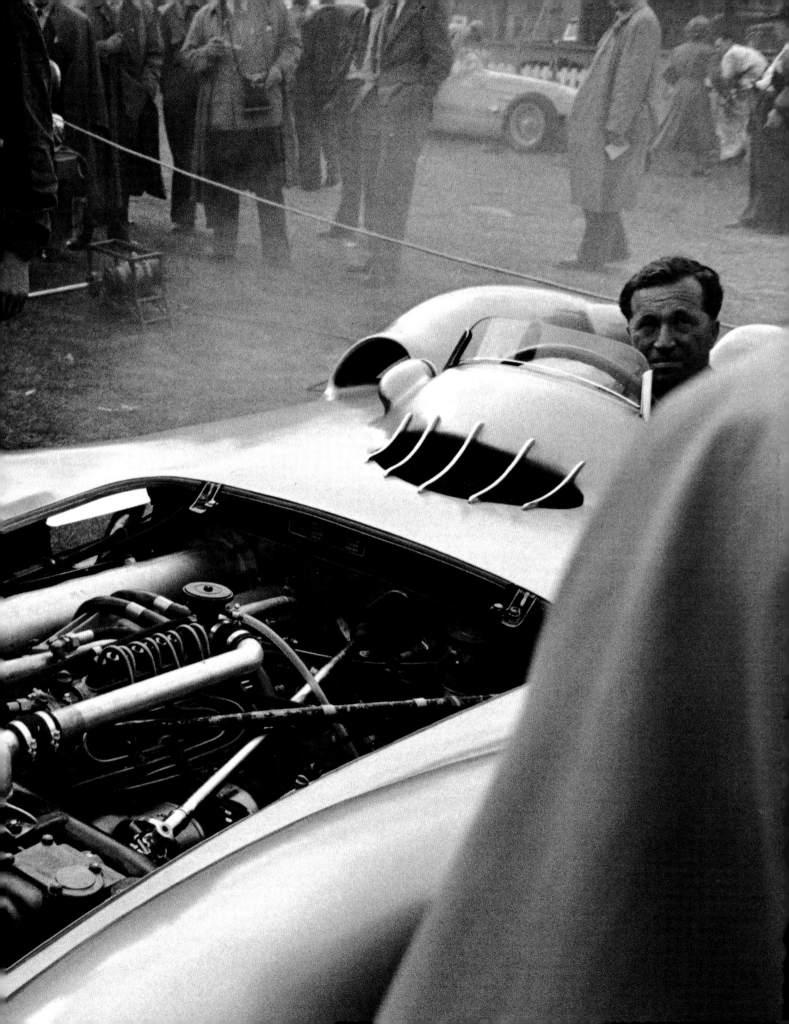

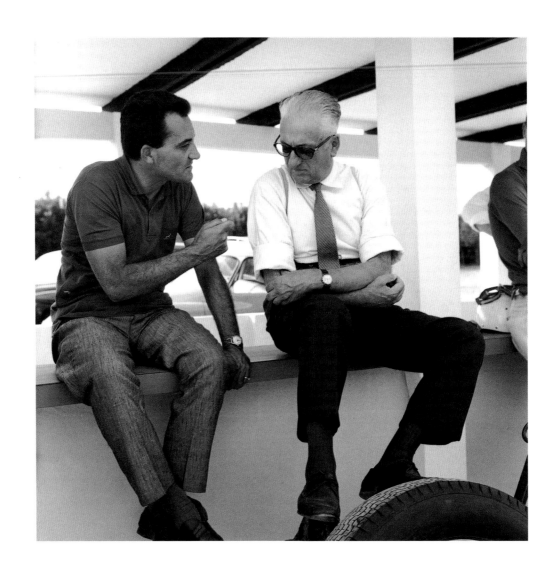

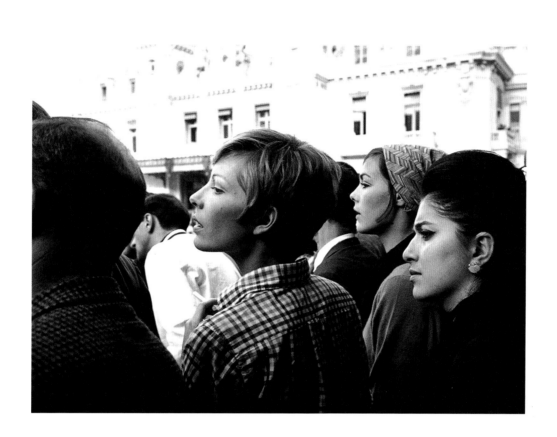

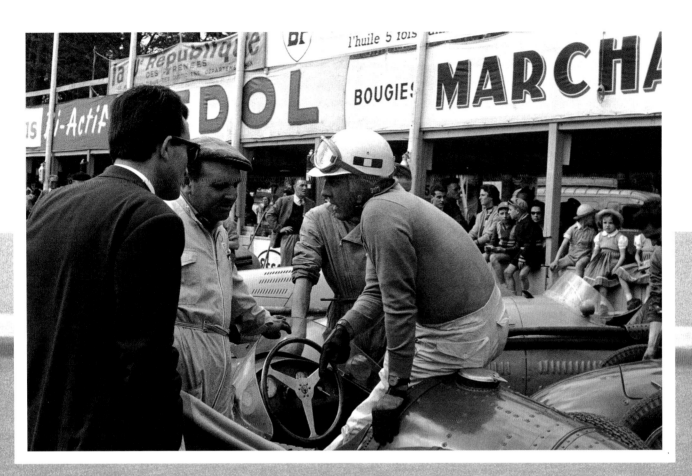

PLATE *13*

19
55

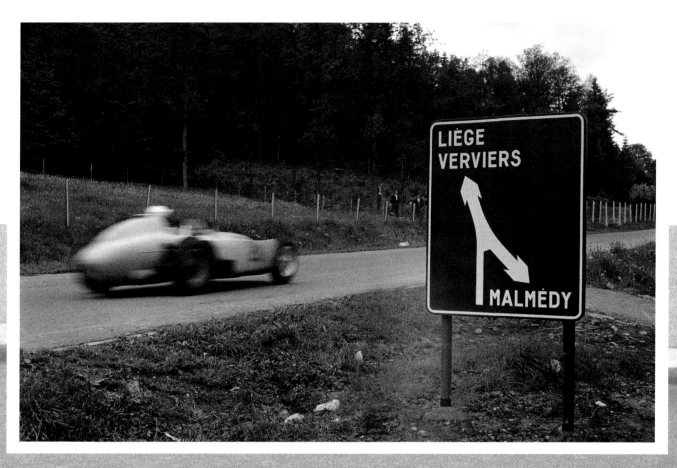

PLATE **14**

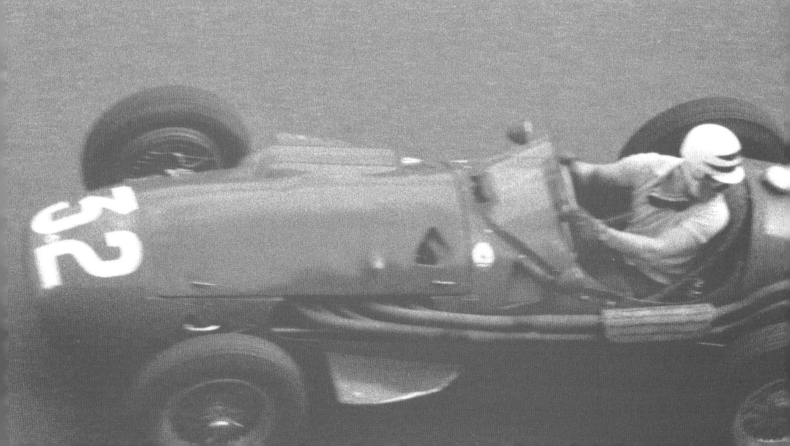

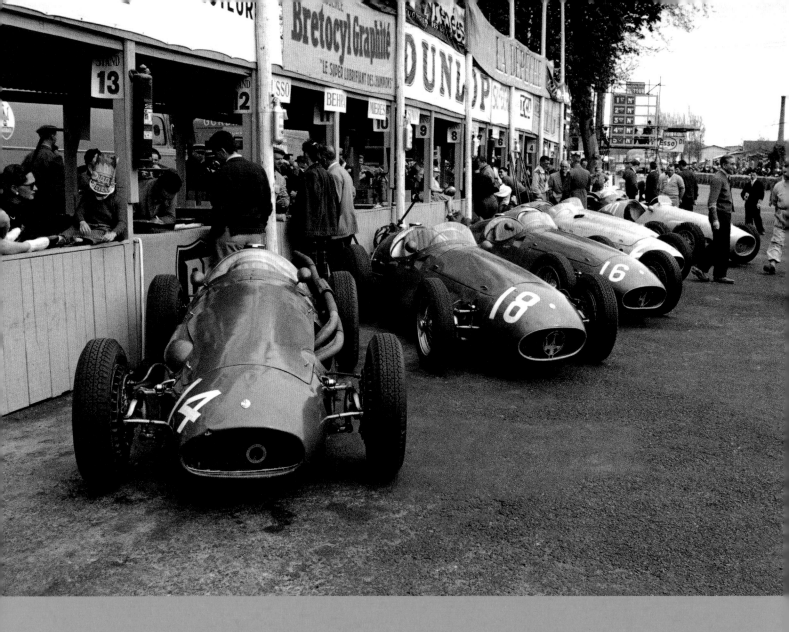

PLATE **15**

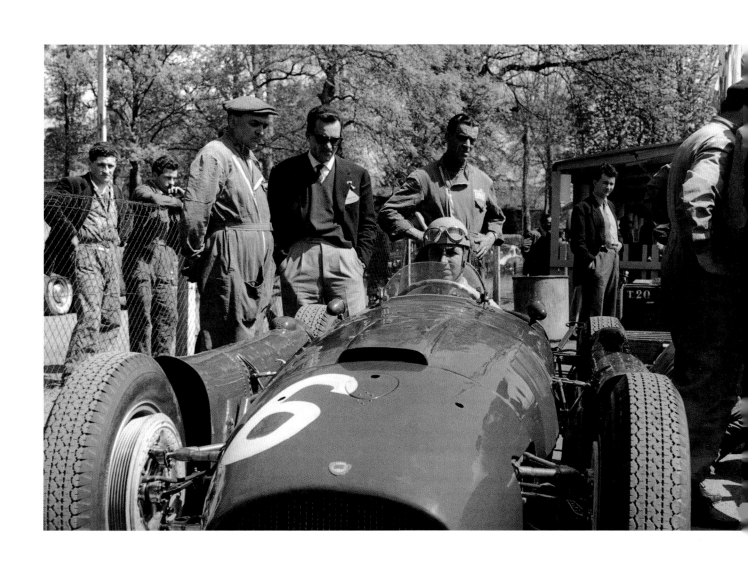

PLATE **16**

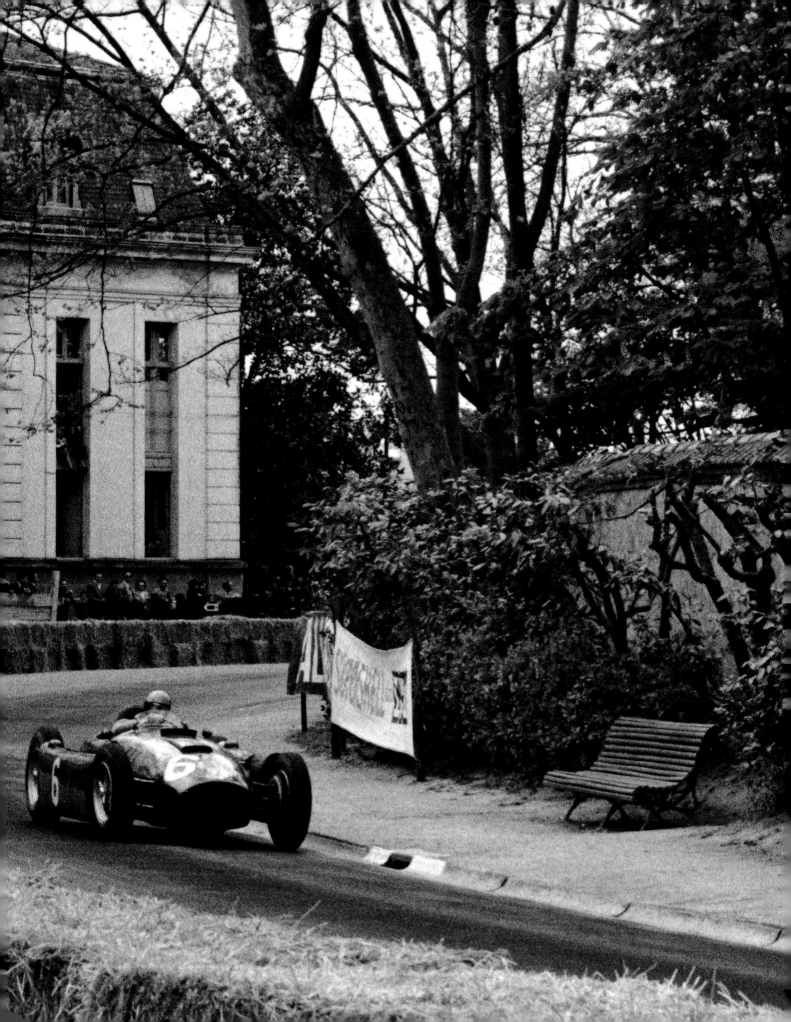

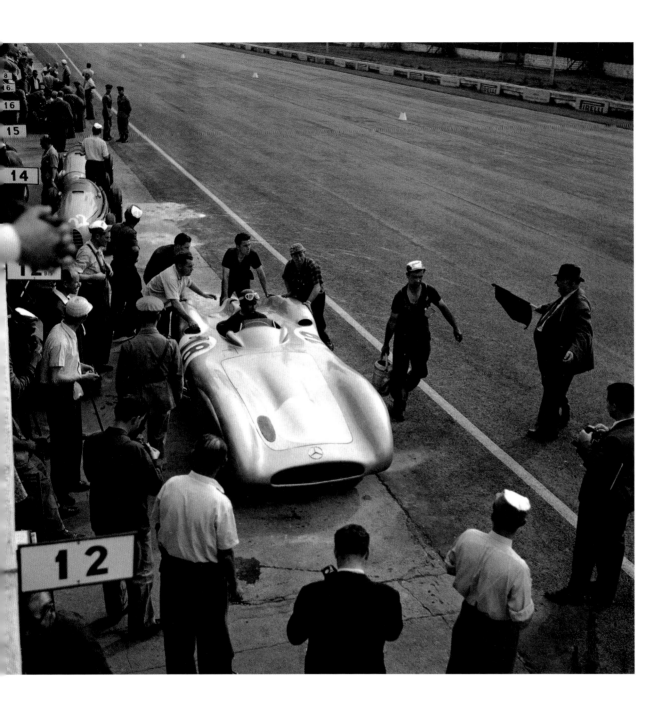

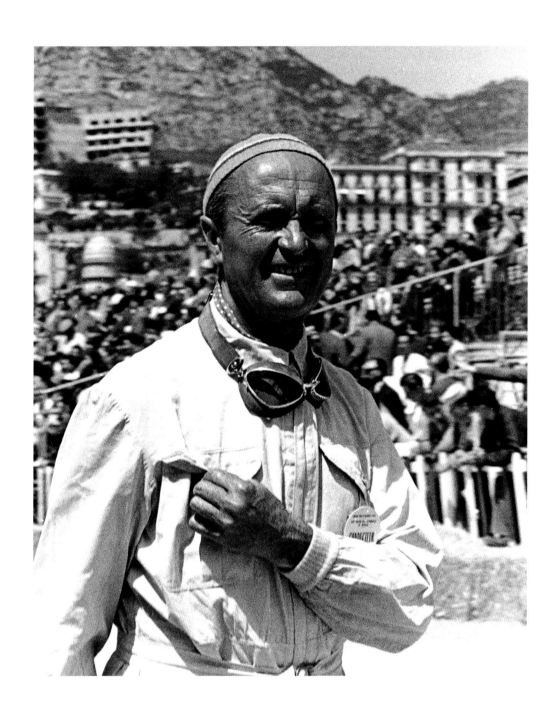

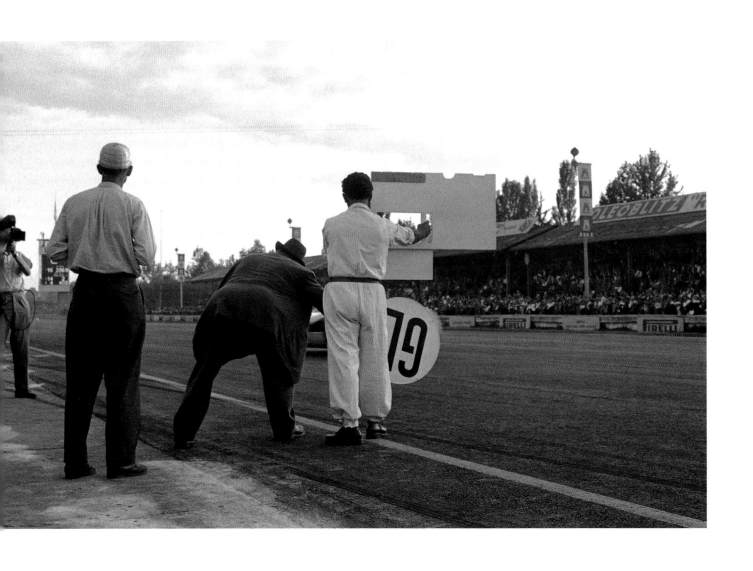

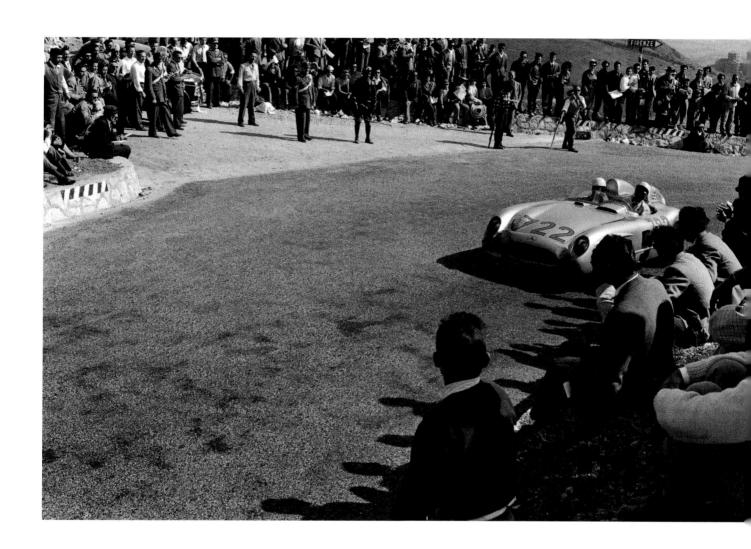

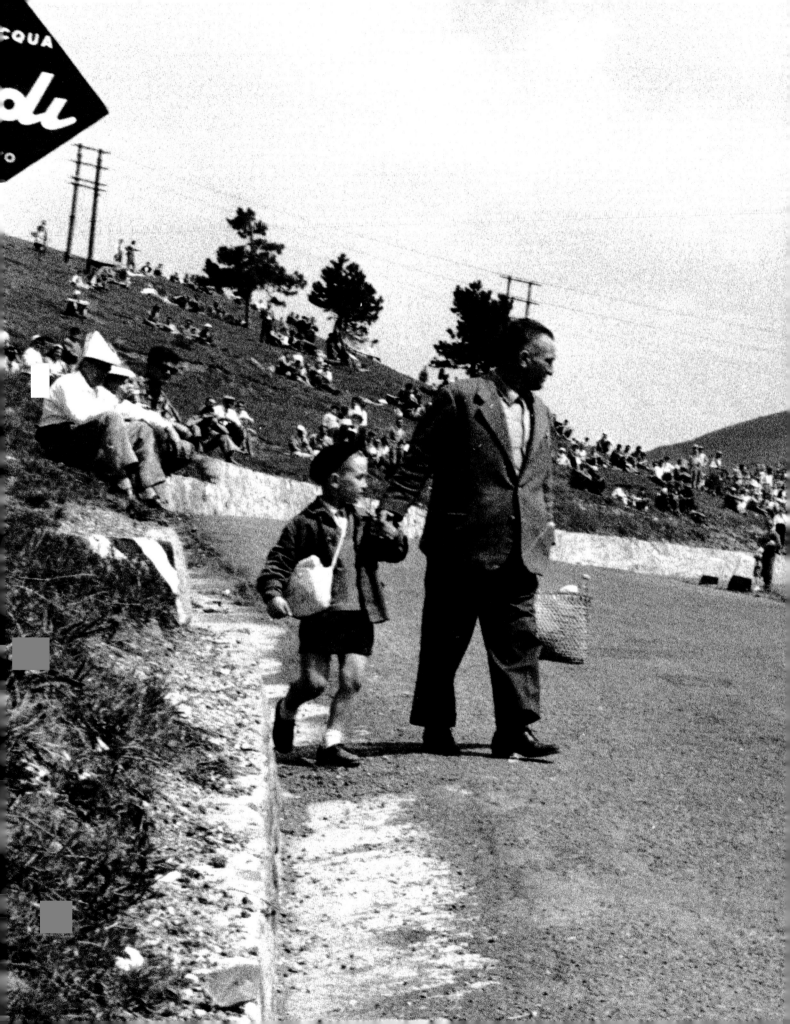

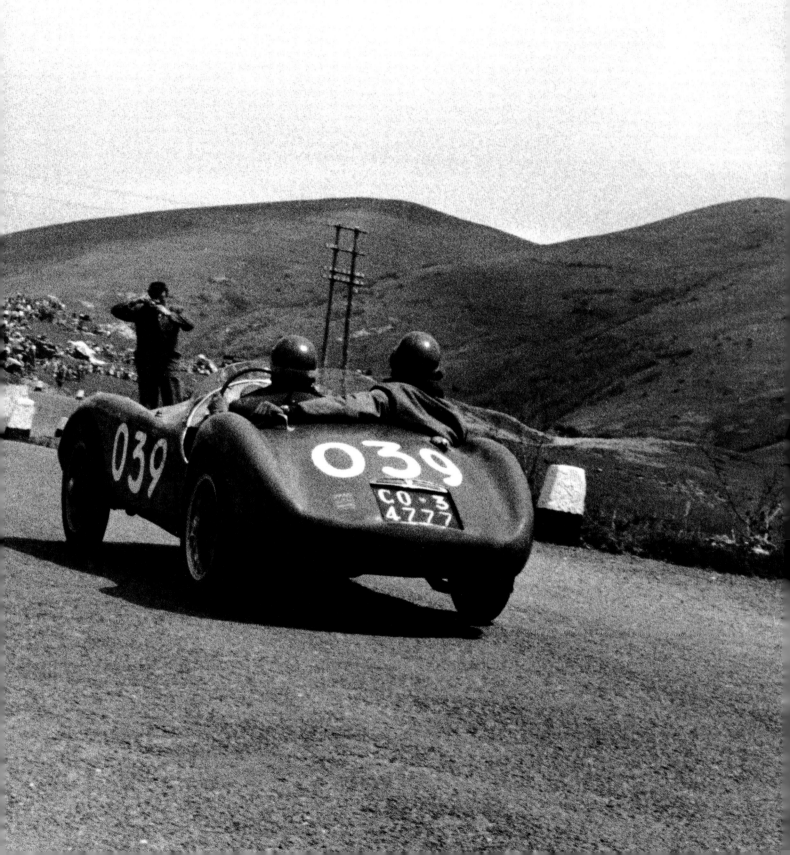

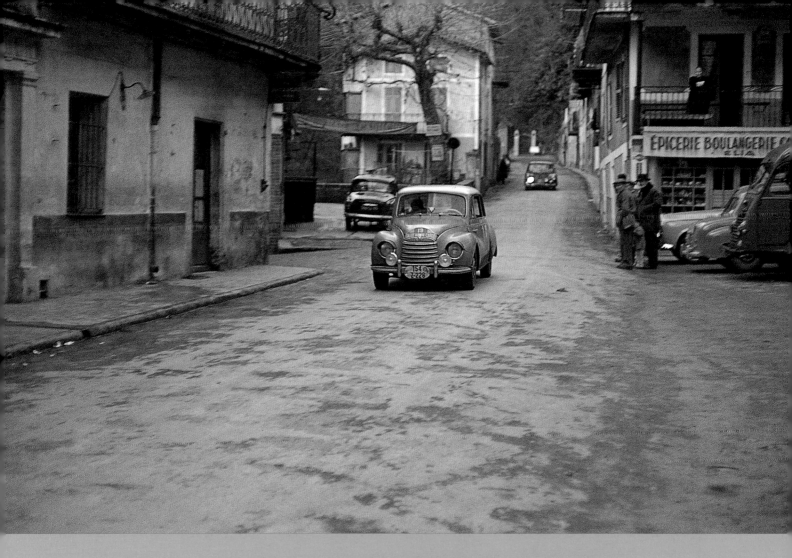

PREVIOUS SPREAD: PLATE **23** ----- ABOVE: PLATE **24** ----- TOP RIGHT: PLATE **25** ----- BOTTOM RIGHT: PLATE **26**

19
56

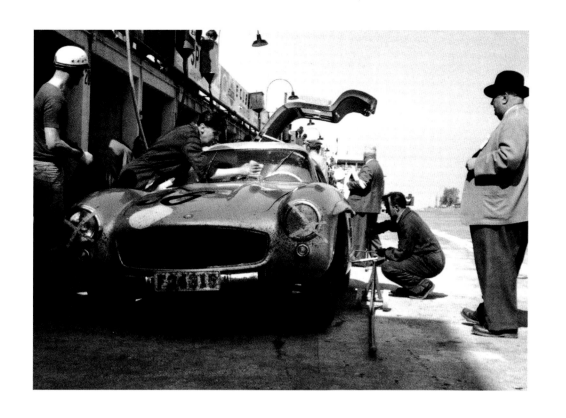

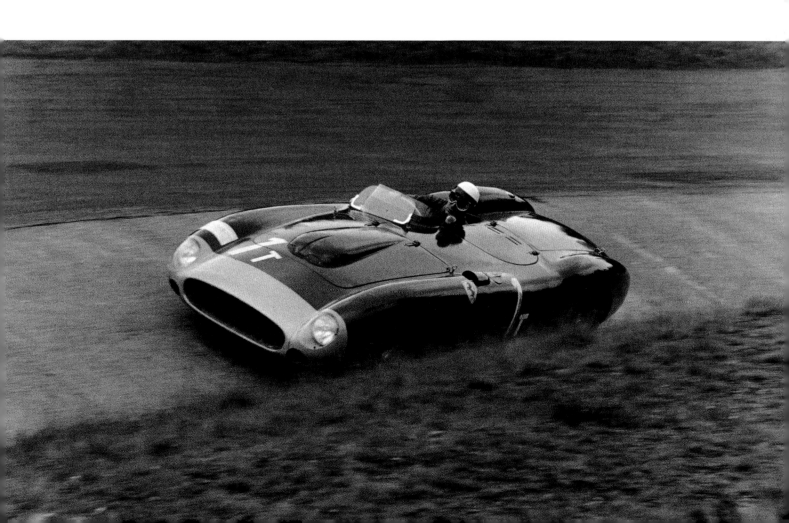

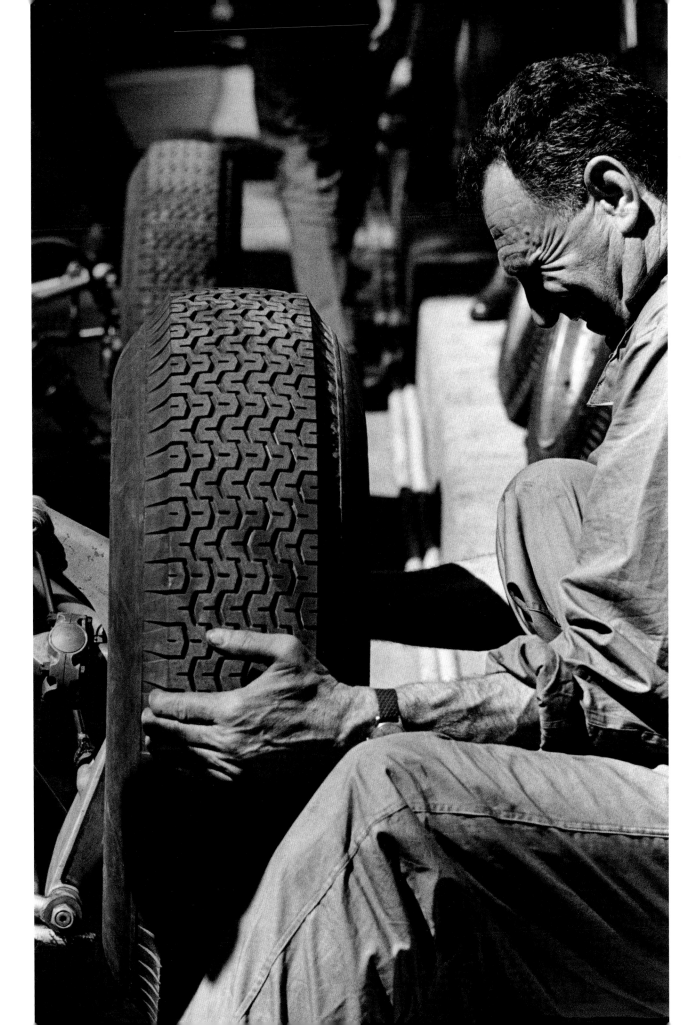

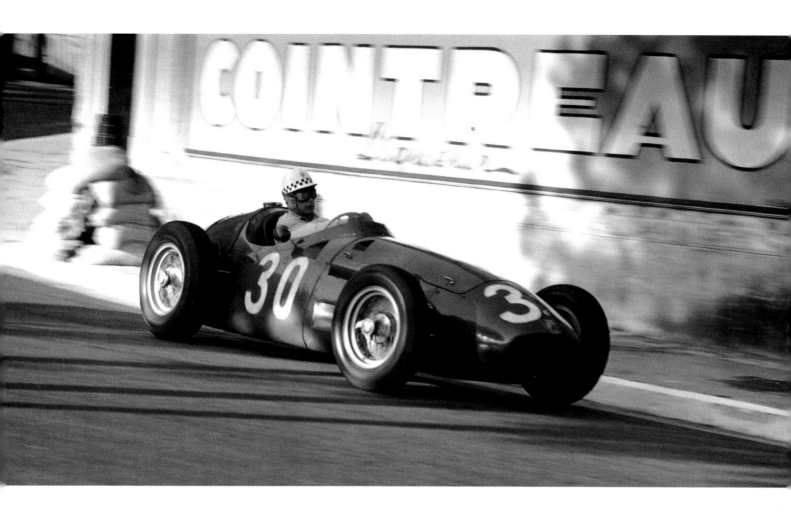

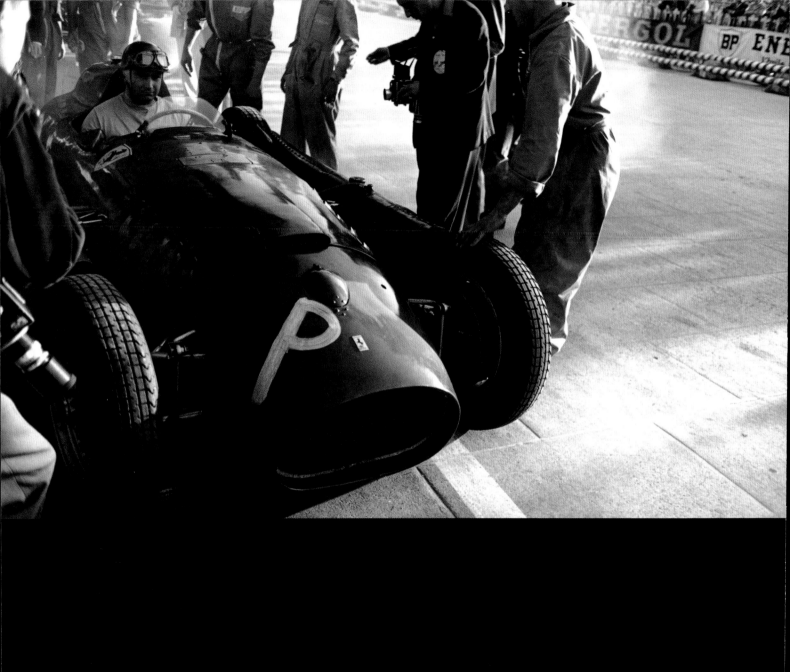

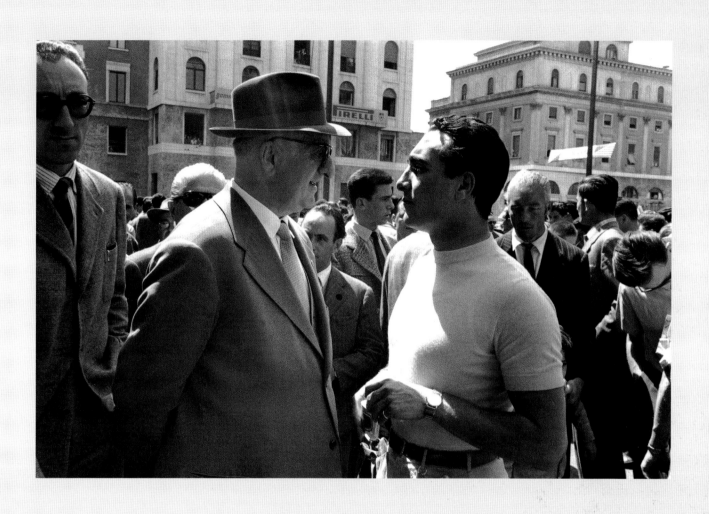

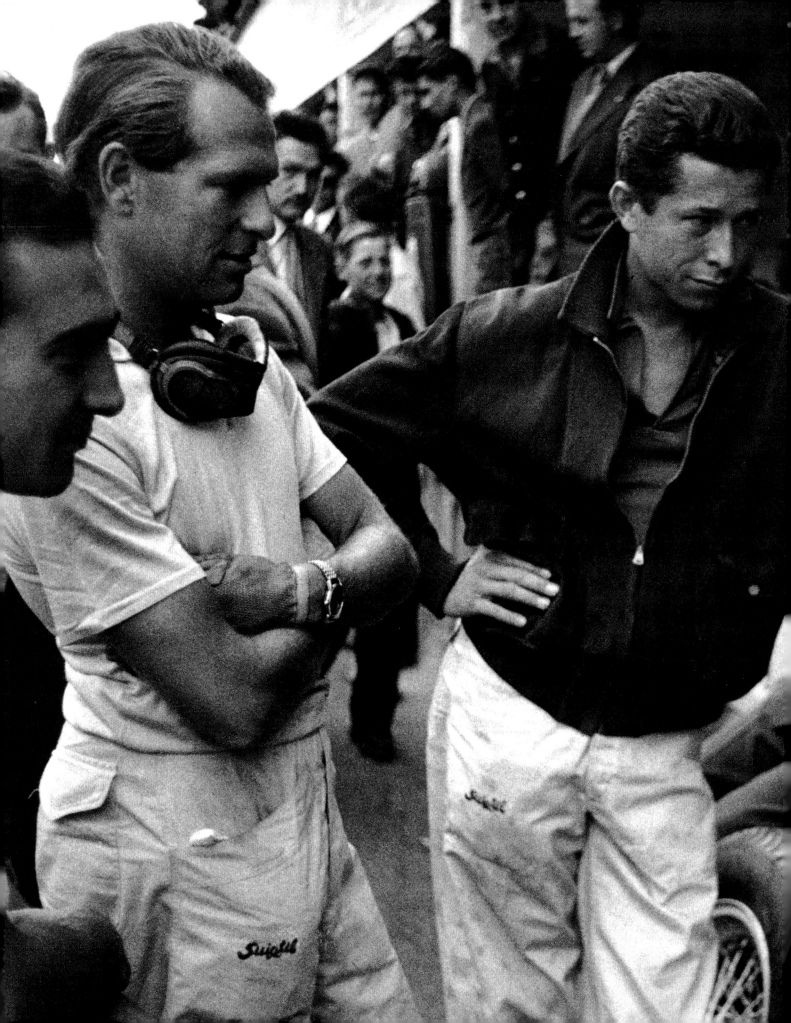

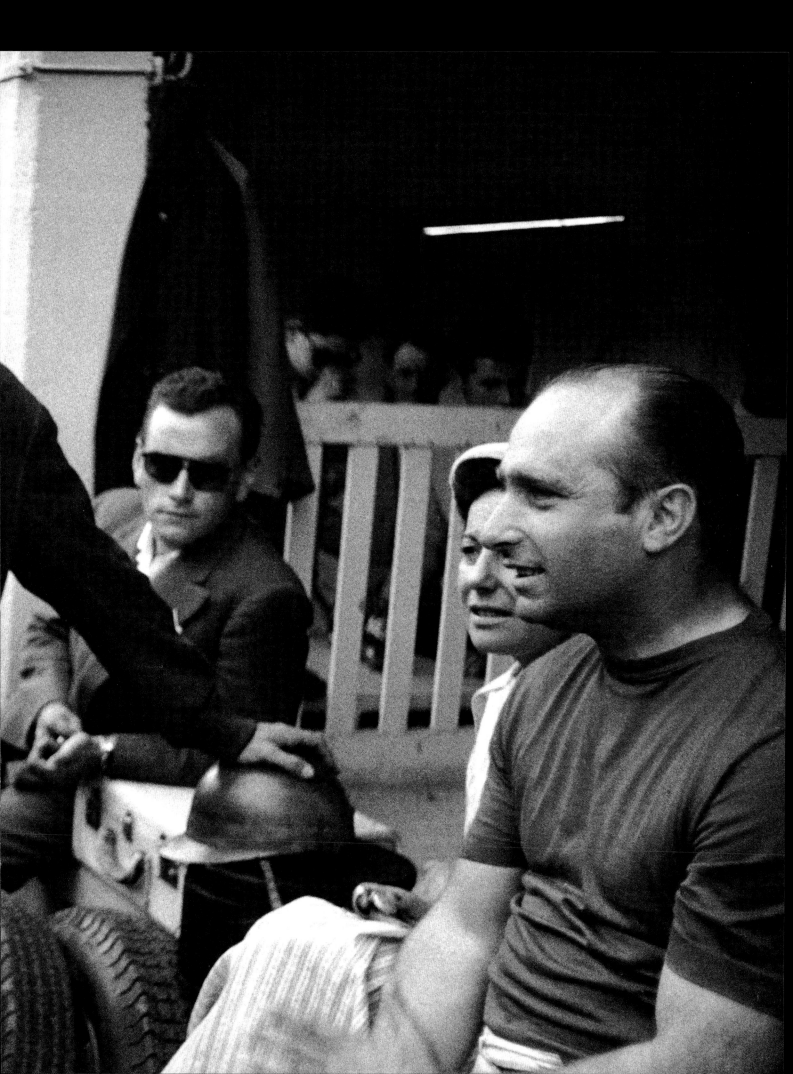

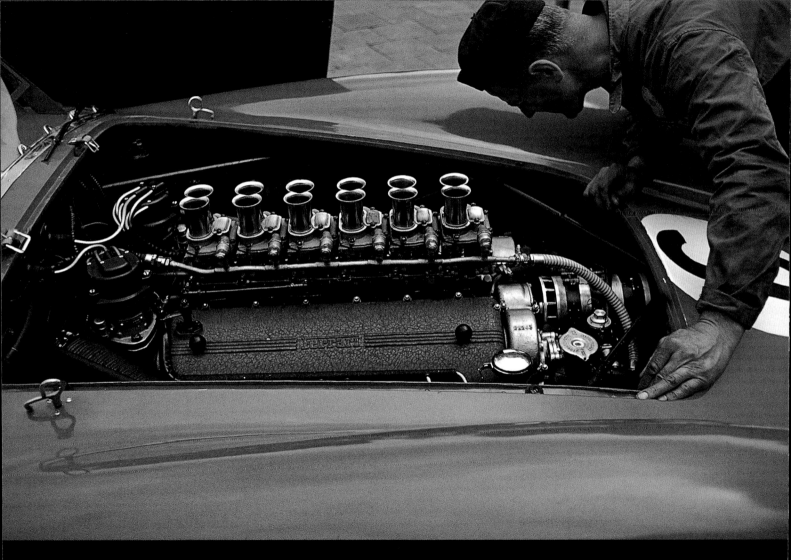

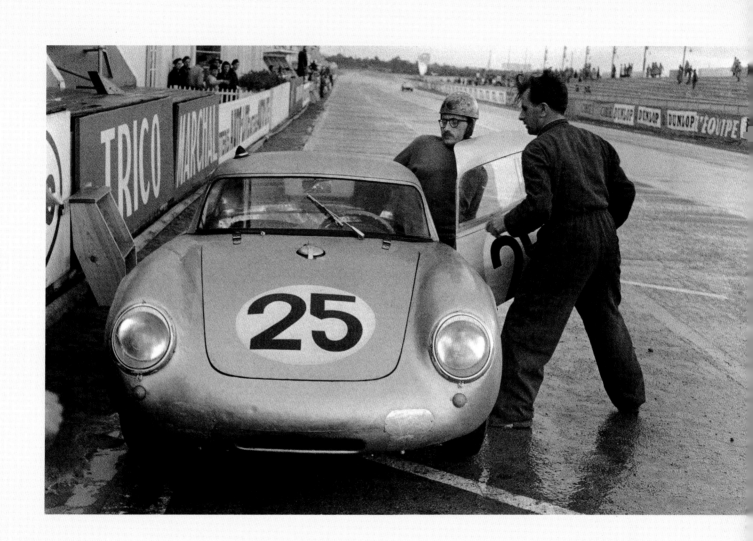

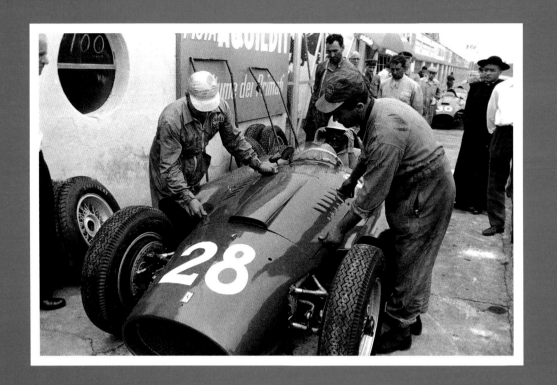

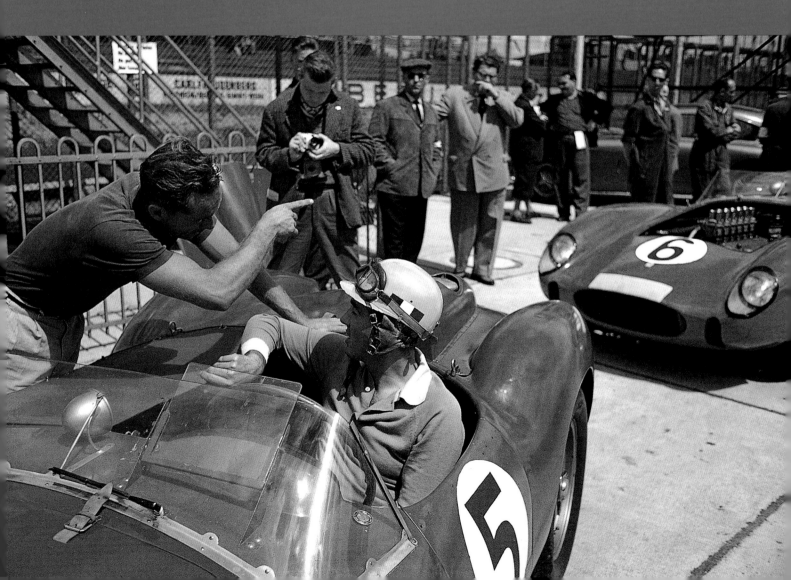

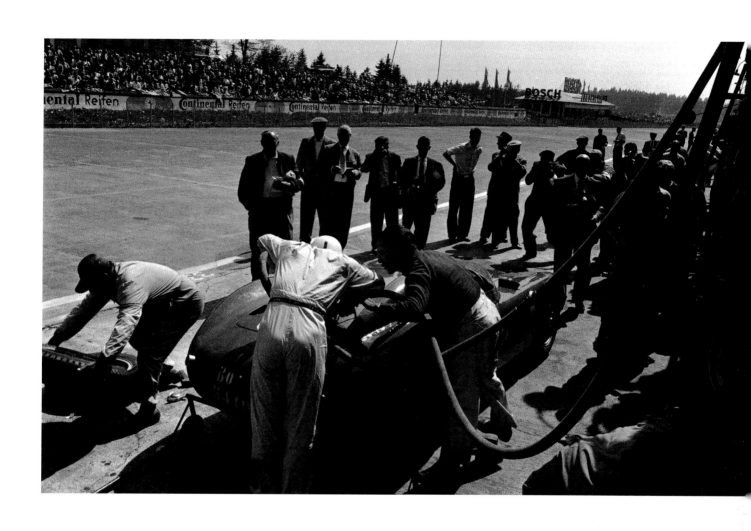

TOP LEFT: PLATE **34** ----- BOTTOM LEFT: PLATE **35** ----- ABOVE: PLATE **36**

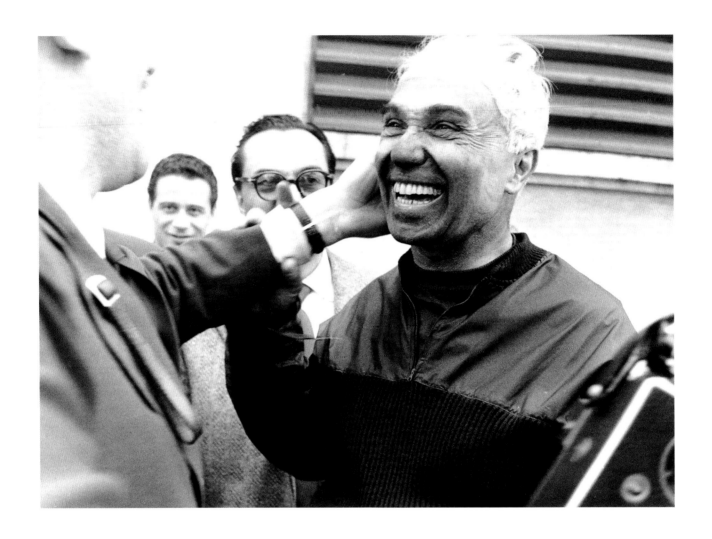

19
57

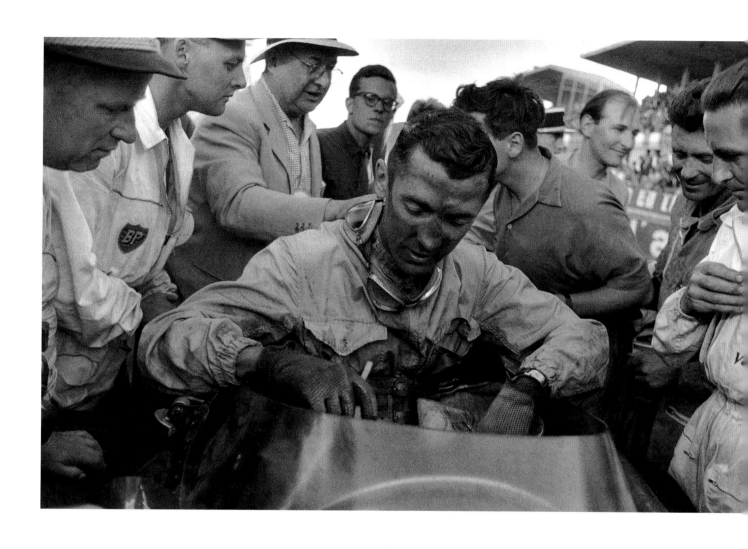

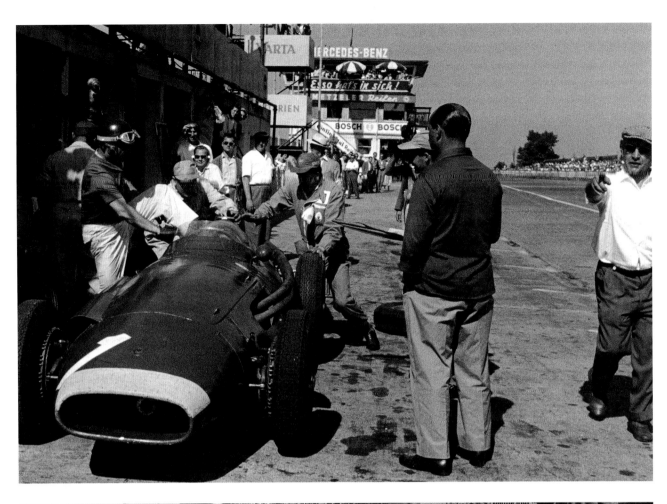

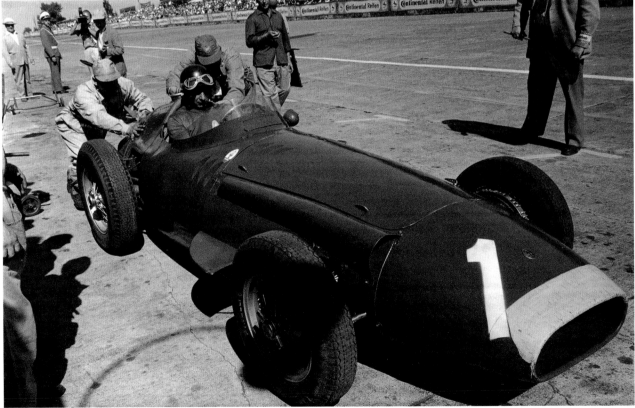

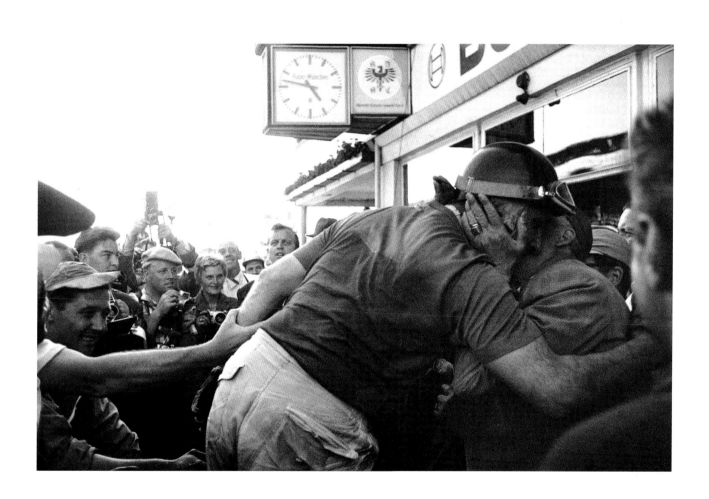

an der Spitze

R

DUNLOP

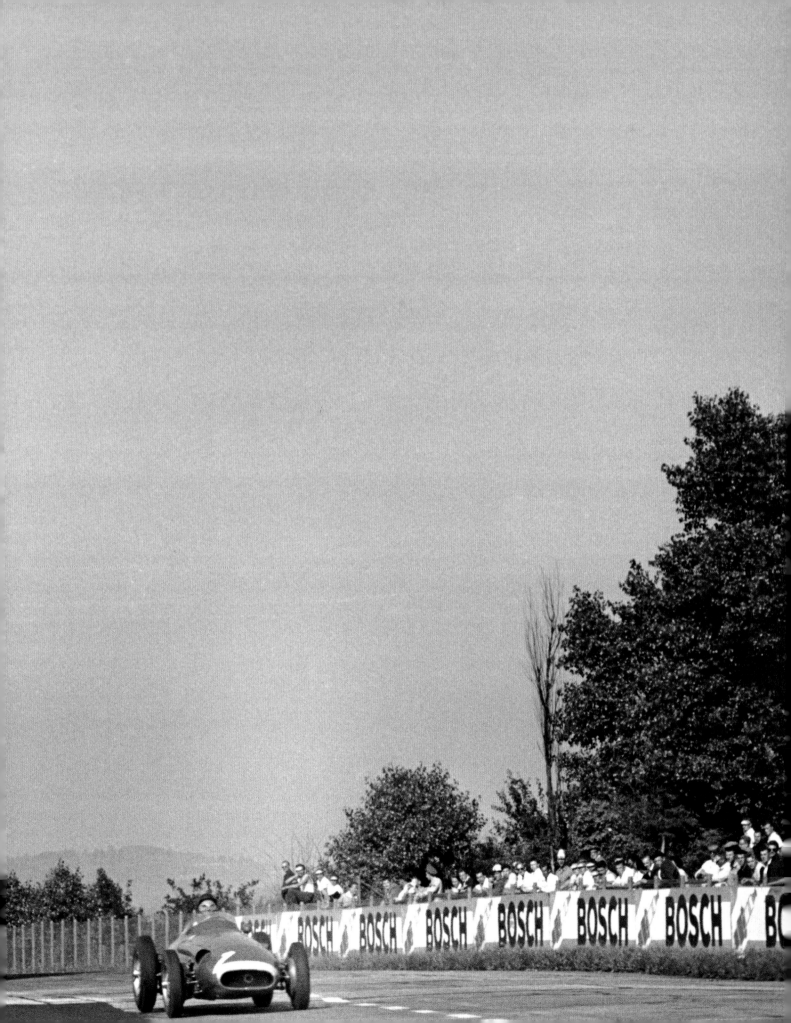

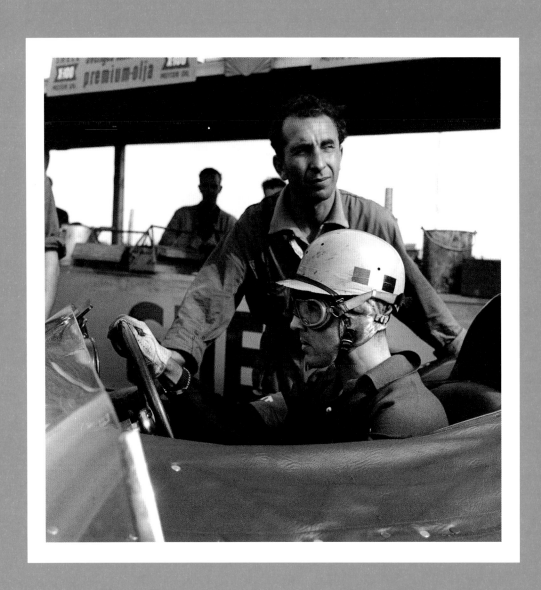

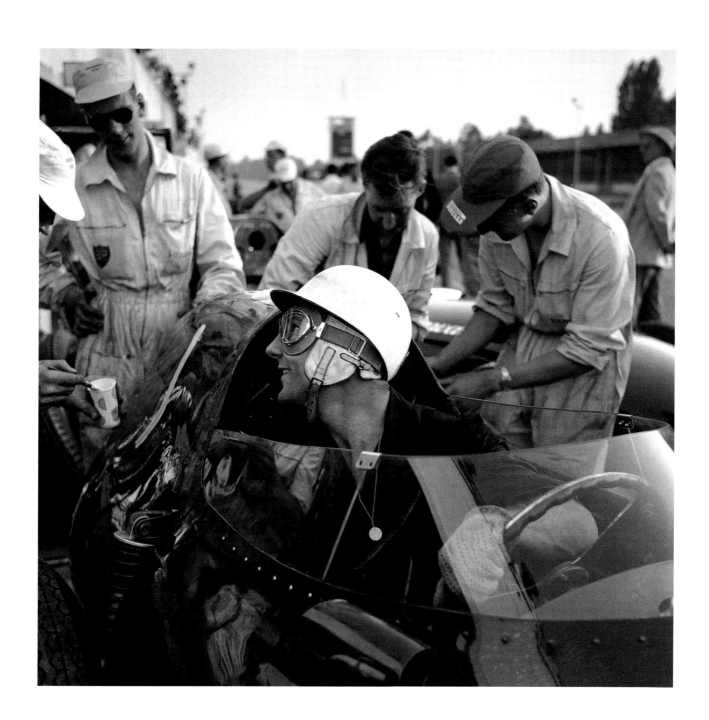

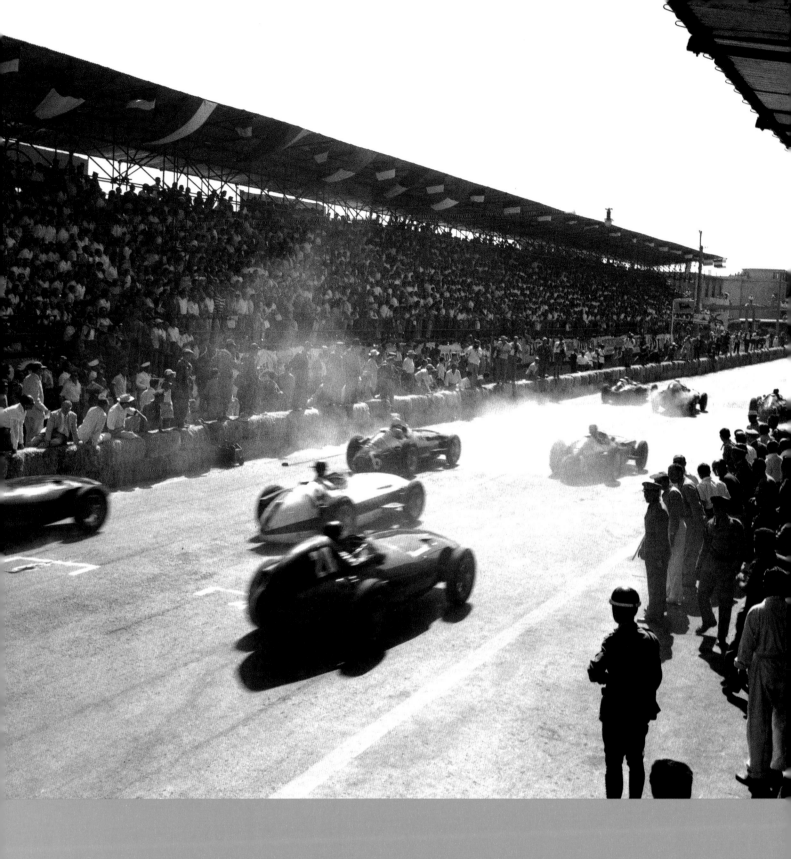

PLATE **44**

PLATE **45**

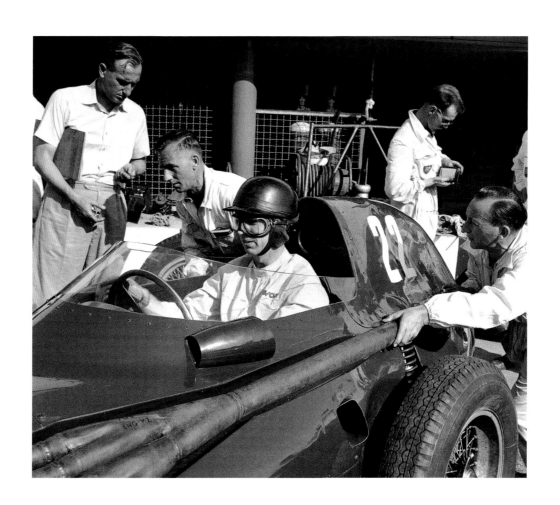

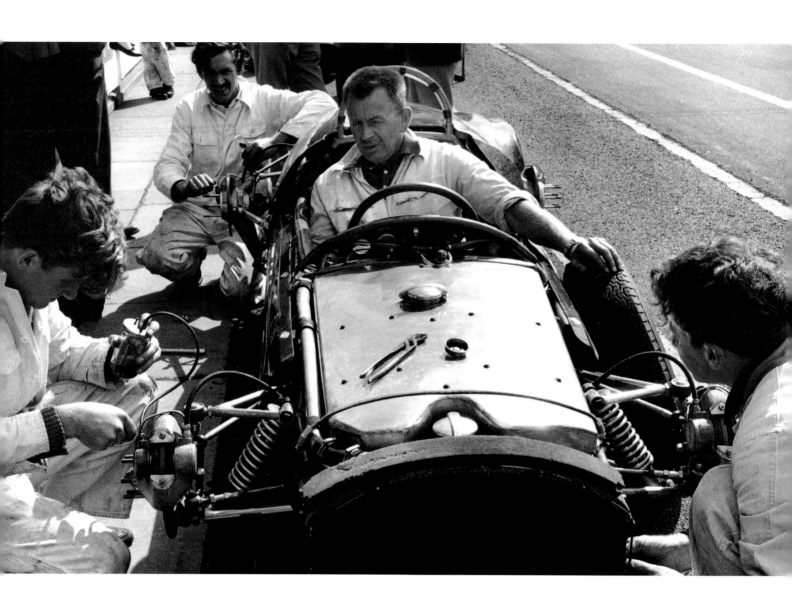

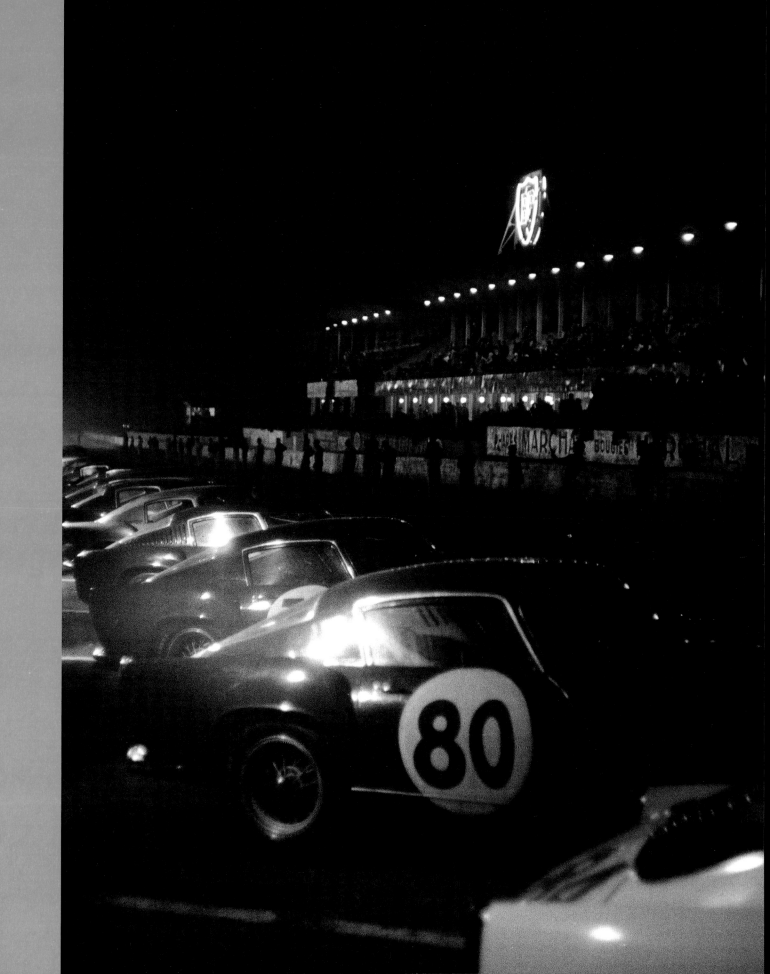

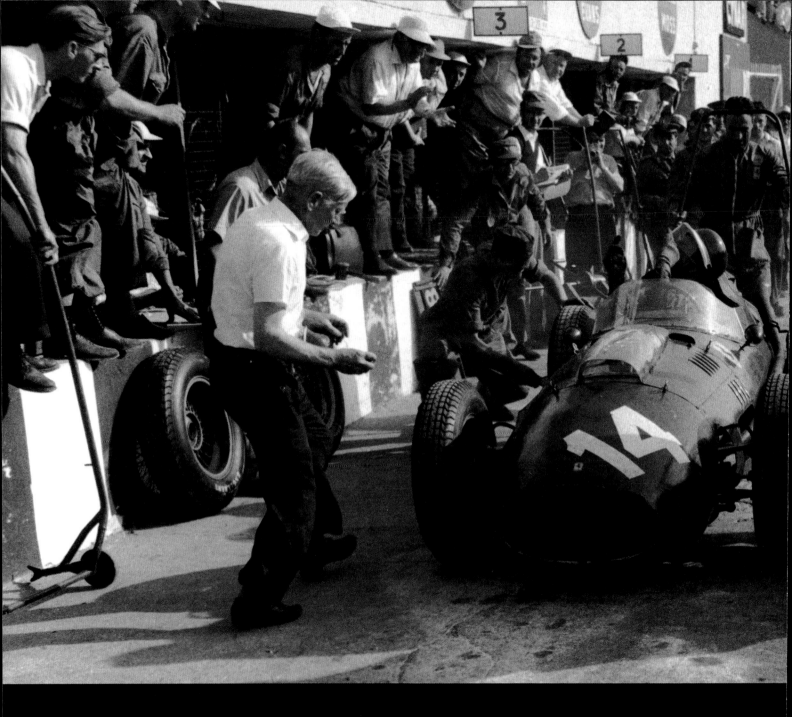

19
58

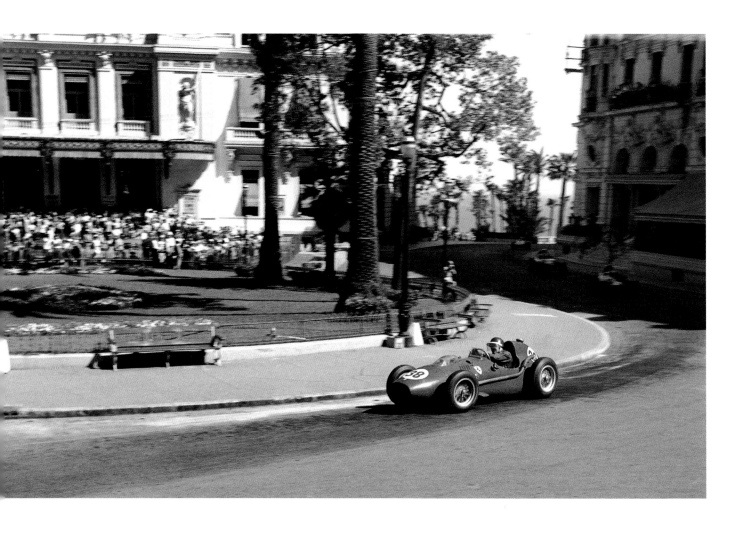

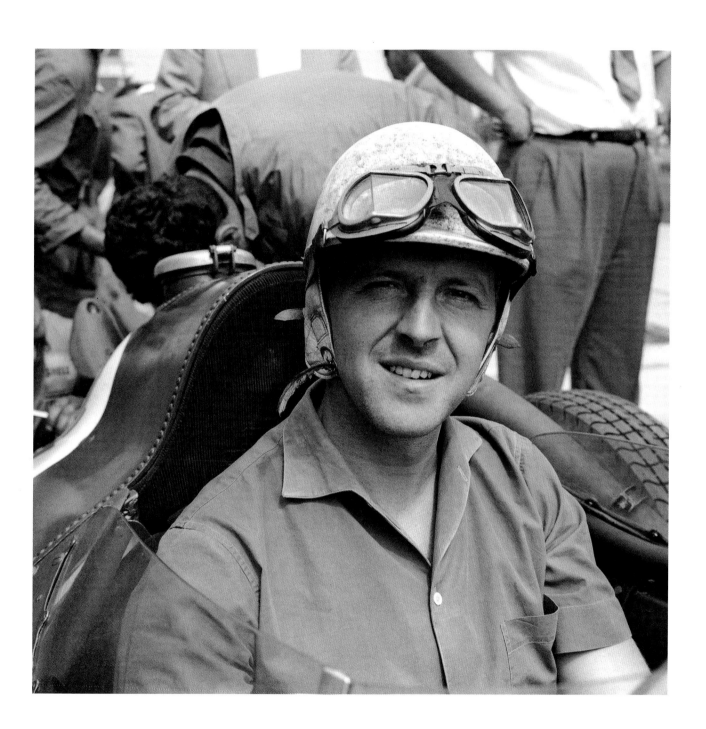

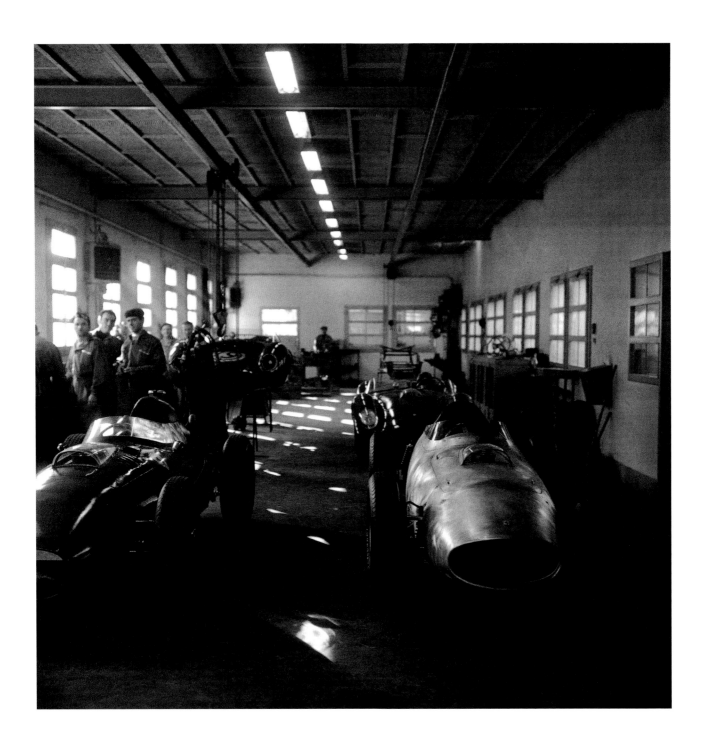

PLATE **51**

PLATE **52**

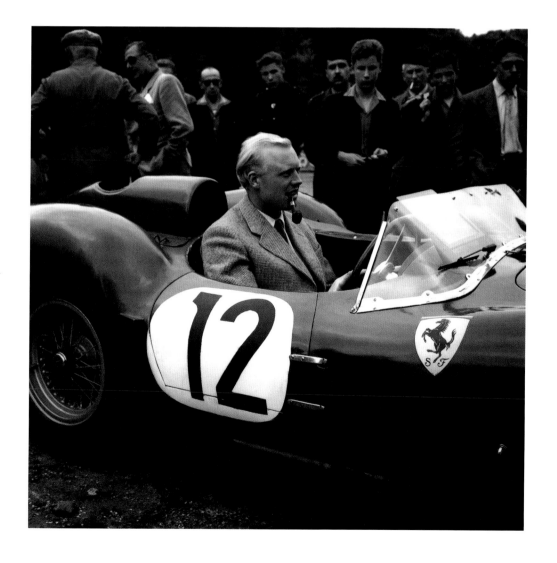

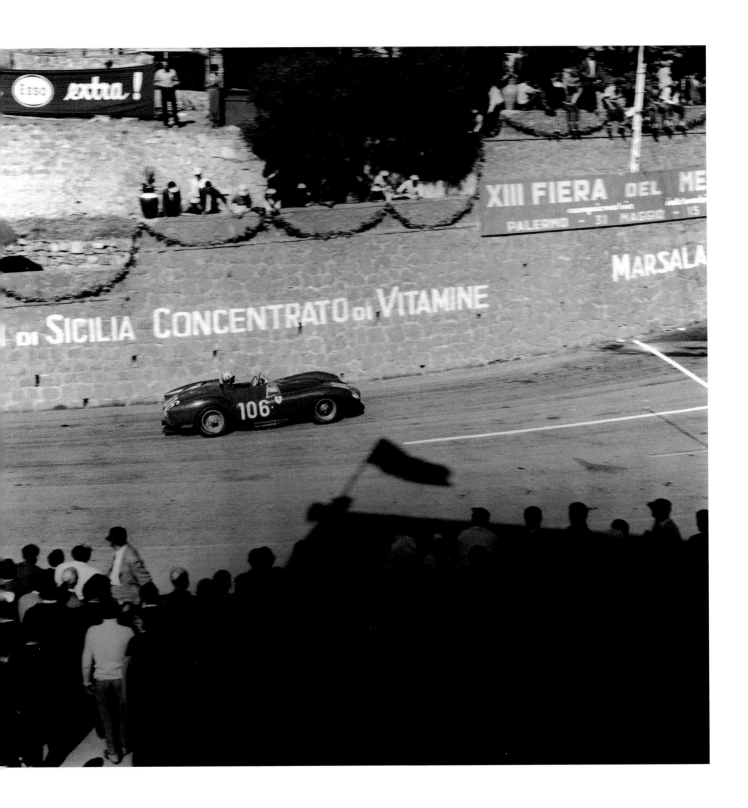

PLATE **53**

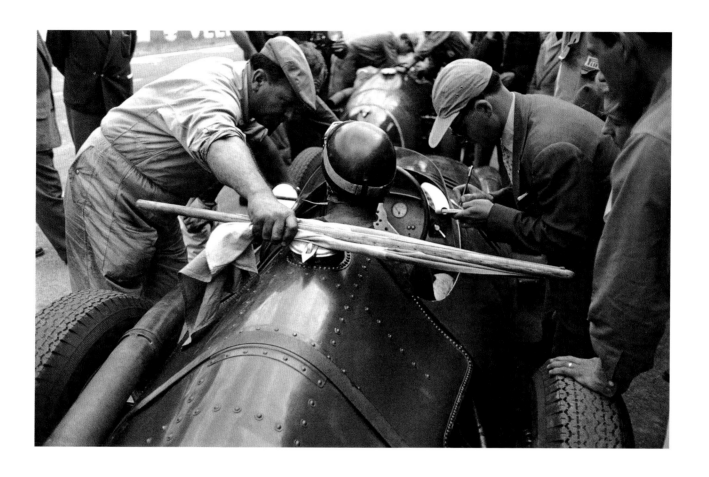

PLATE **54**

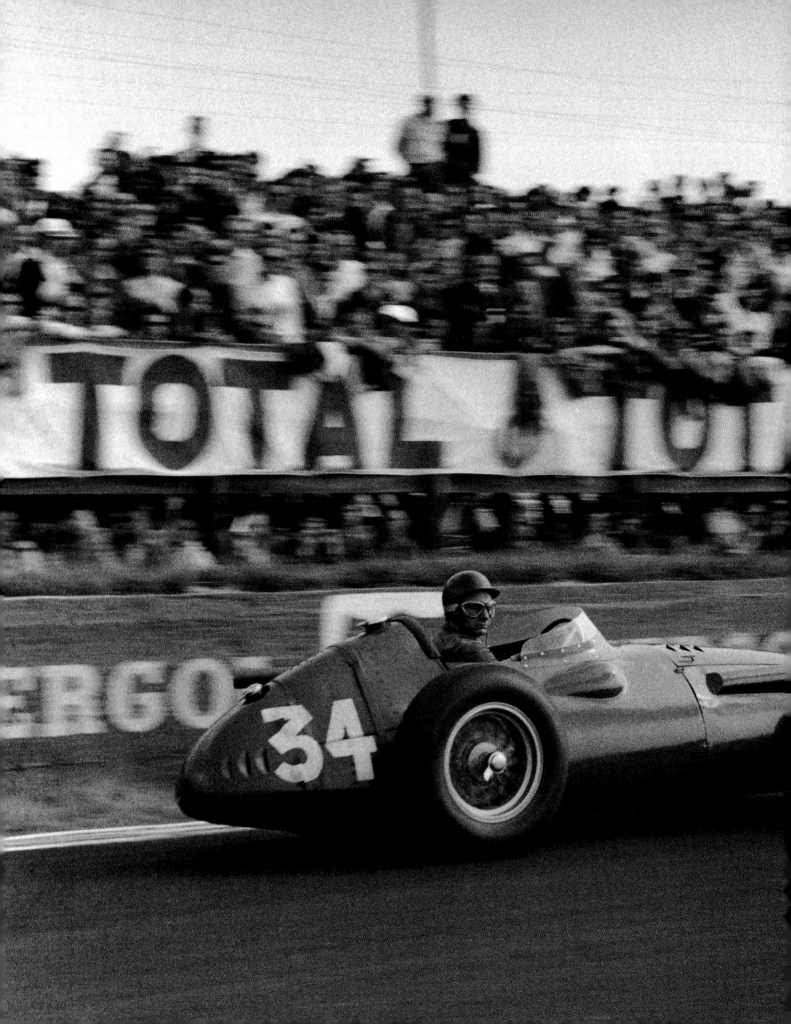

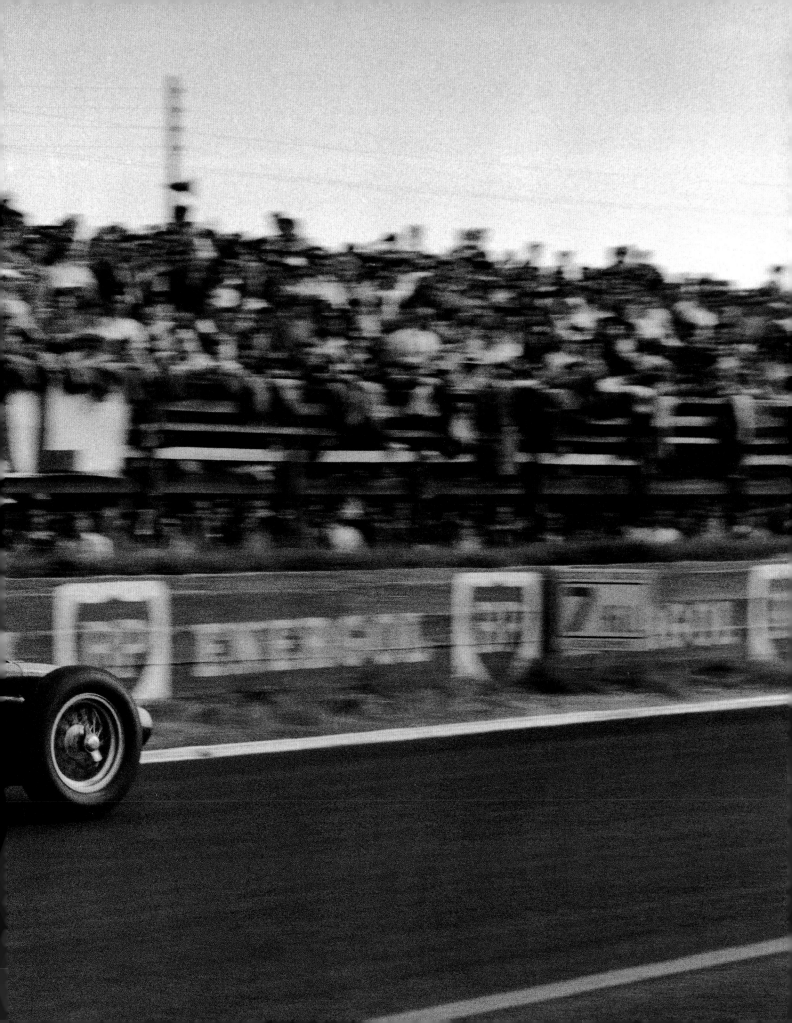

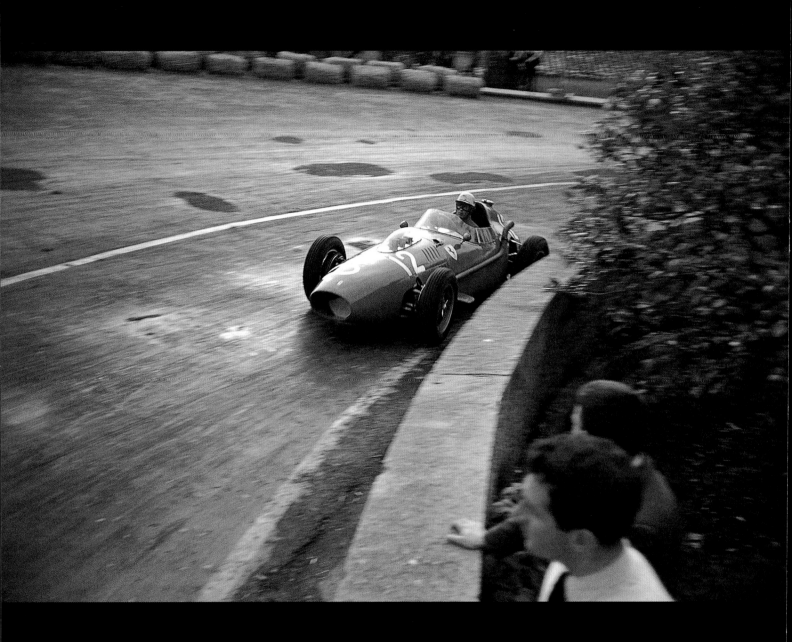

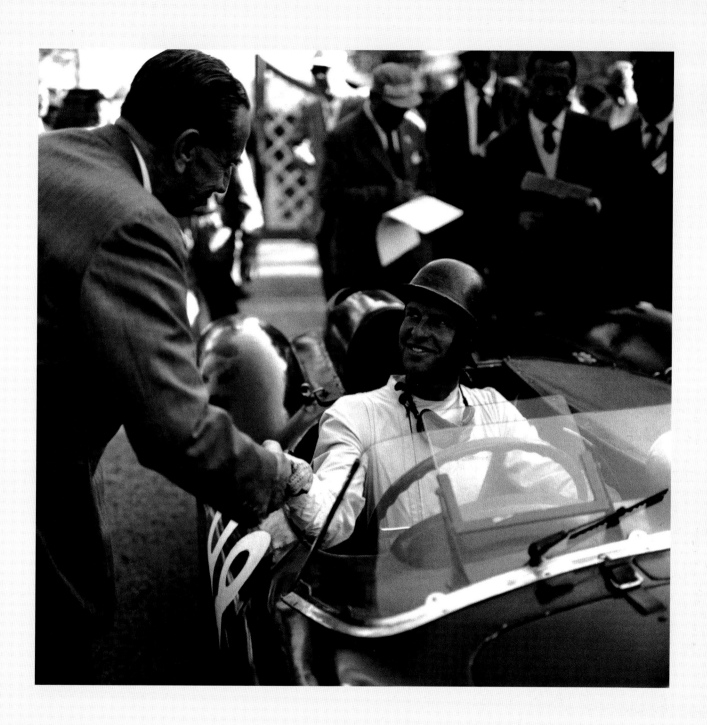

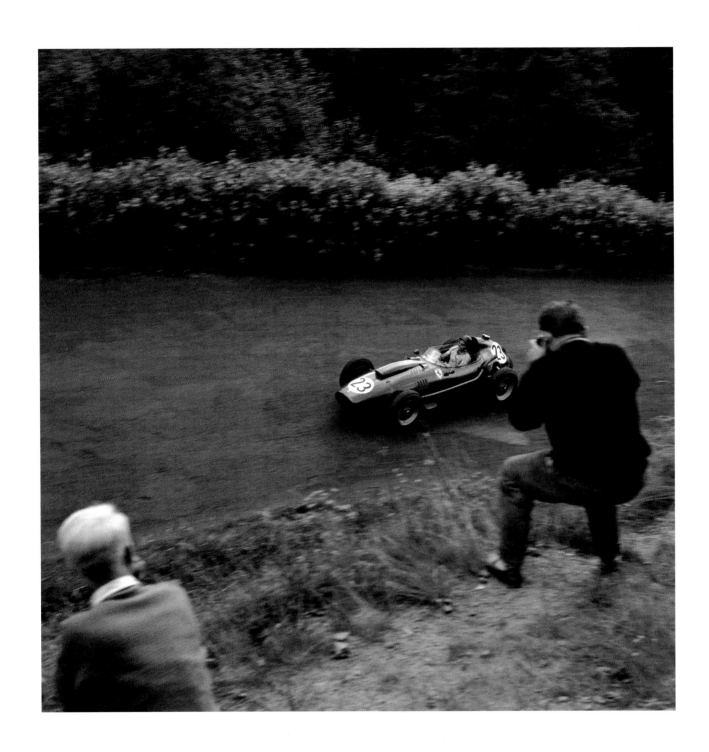

PLATE **58**

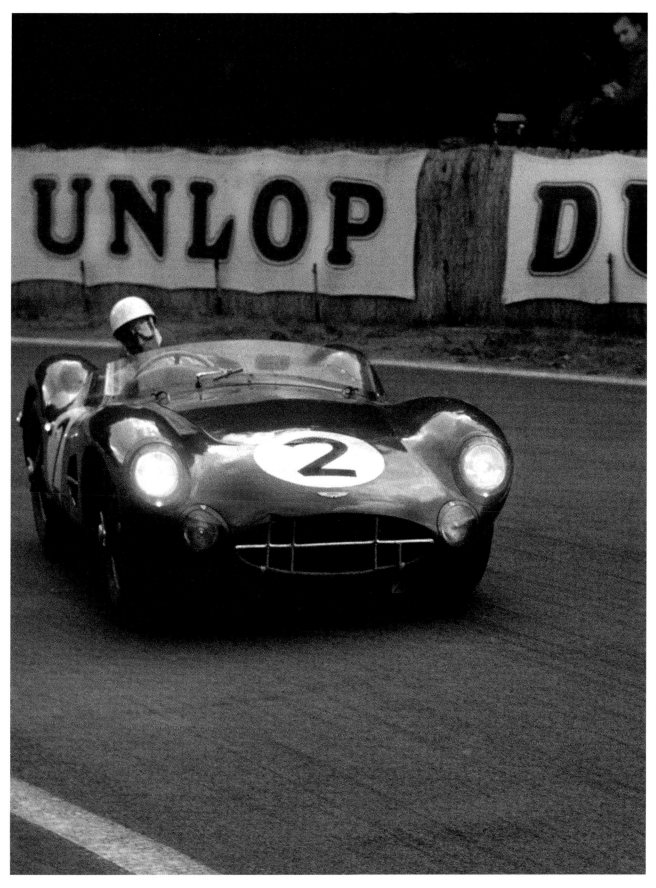

PLATE **59**

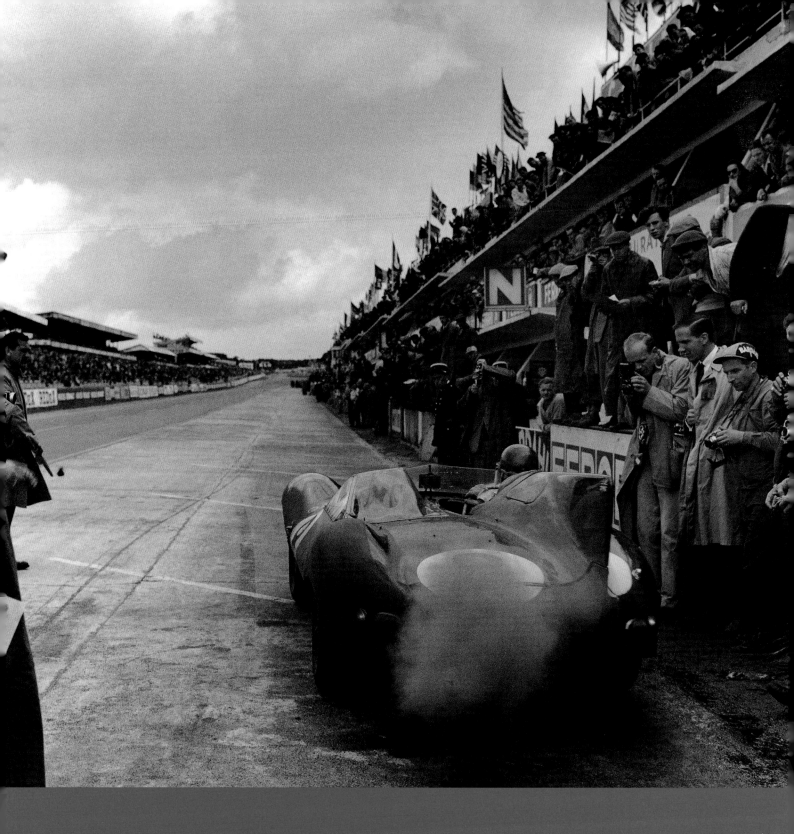

PLATE **60**

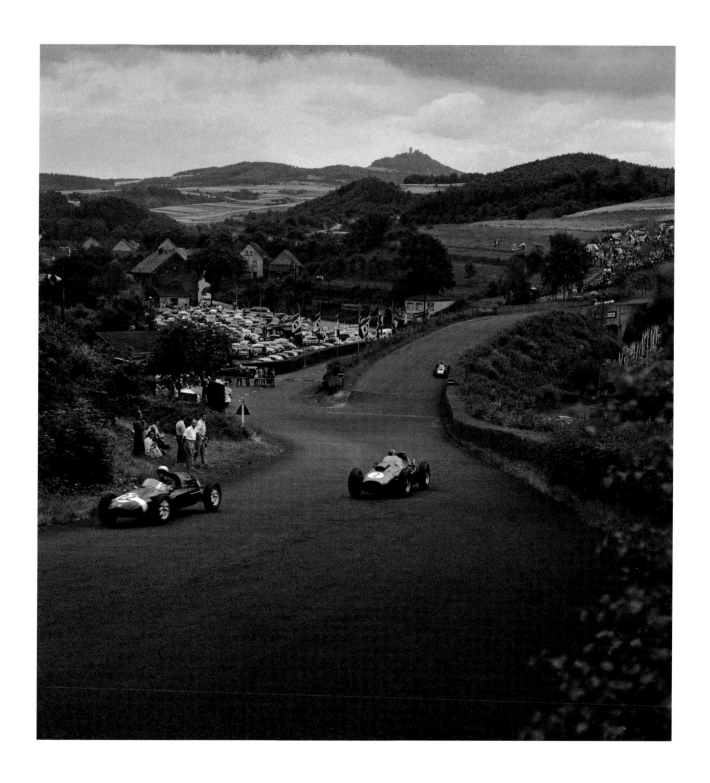

PLATE **61**

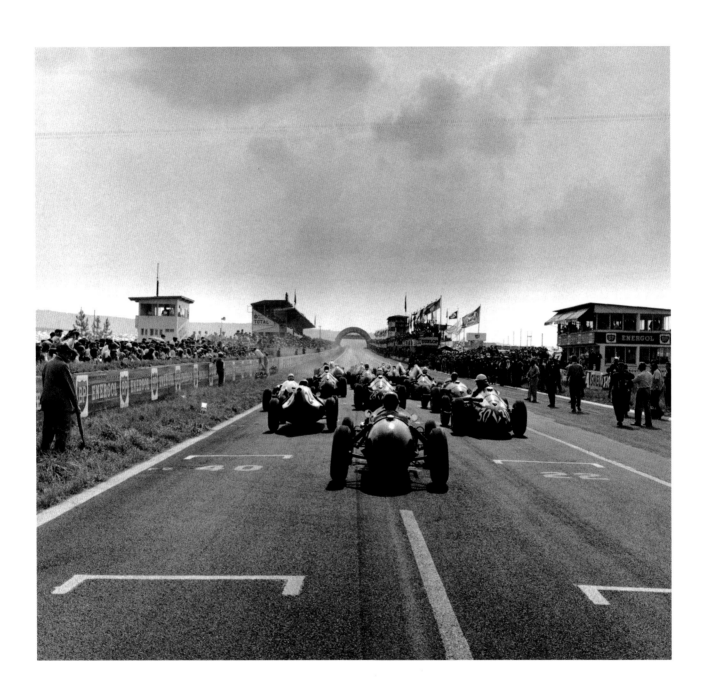

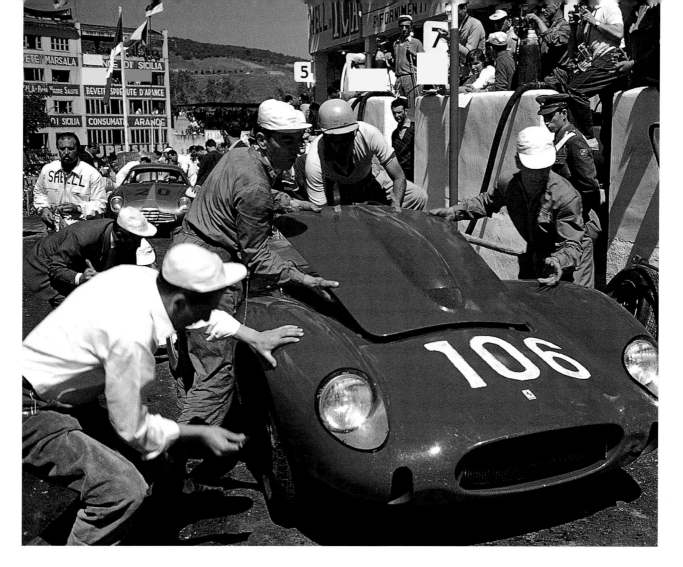

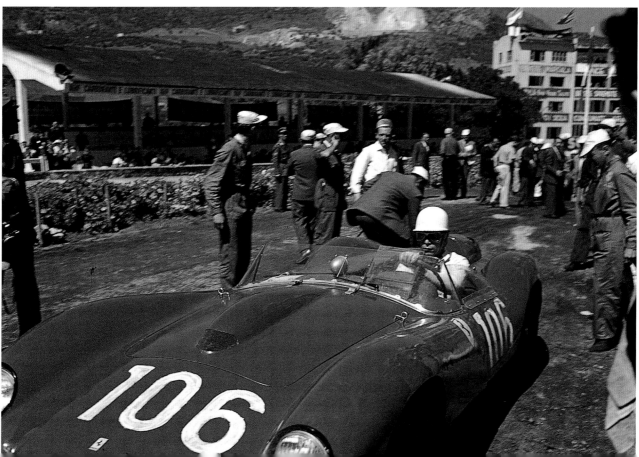

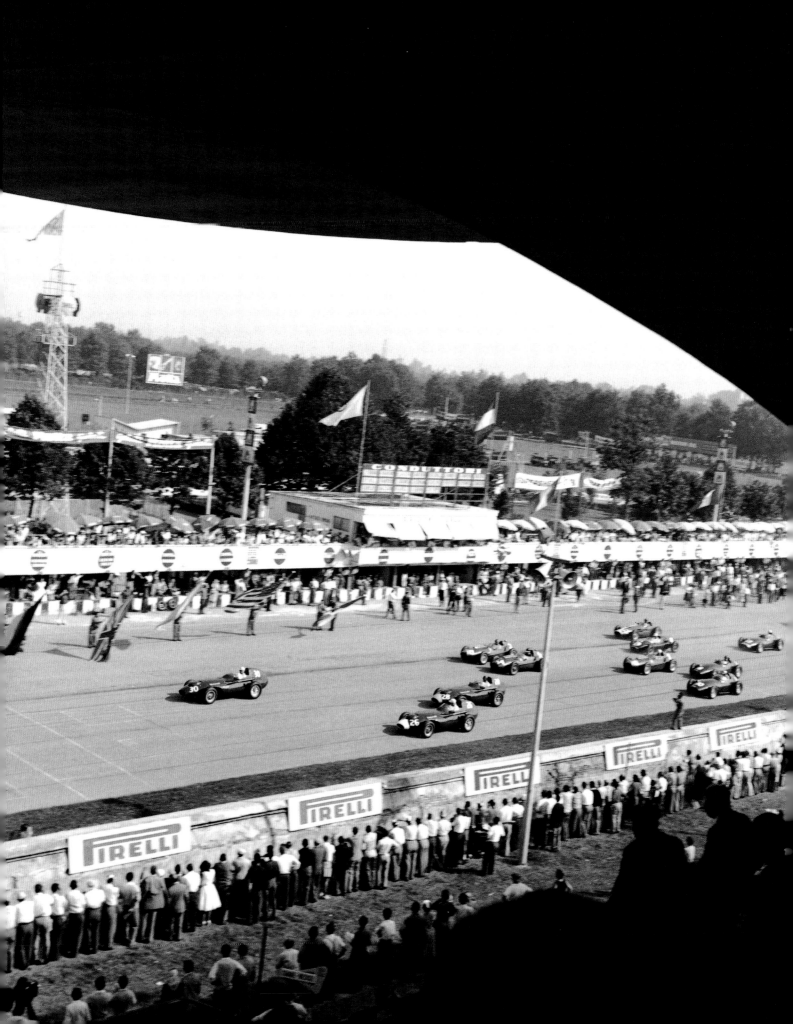

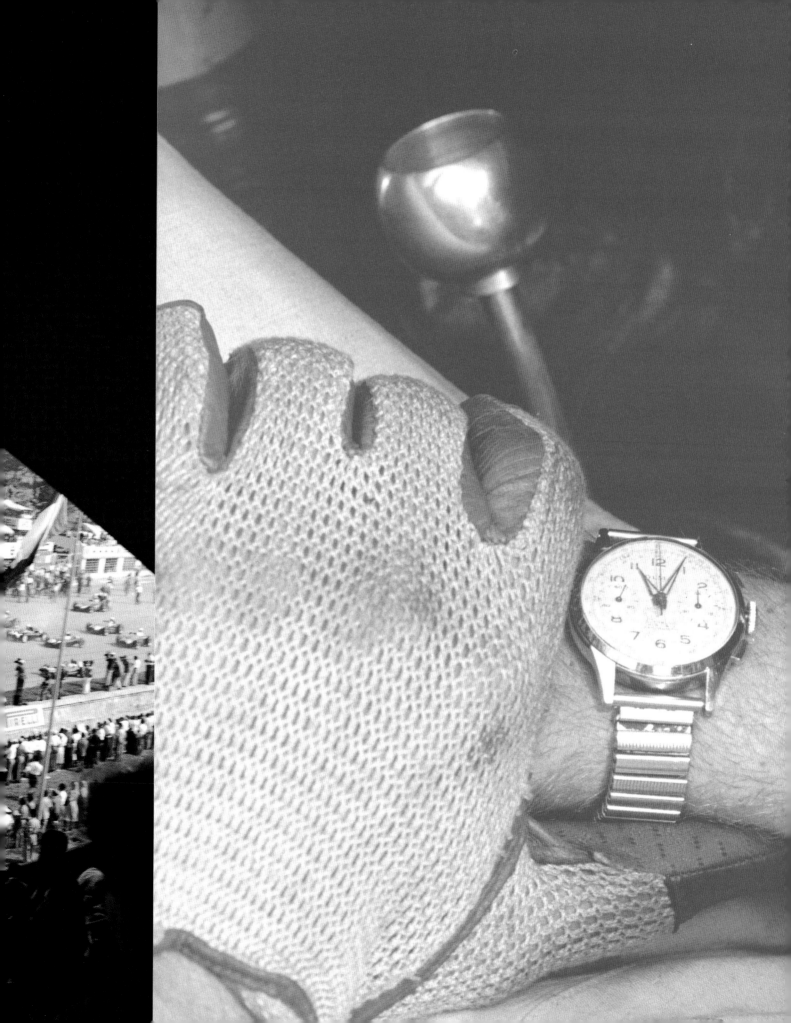

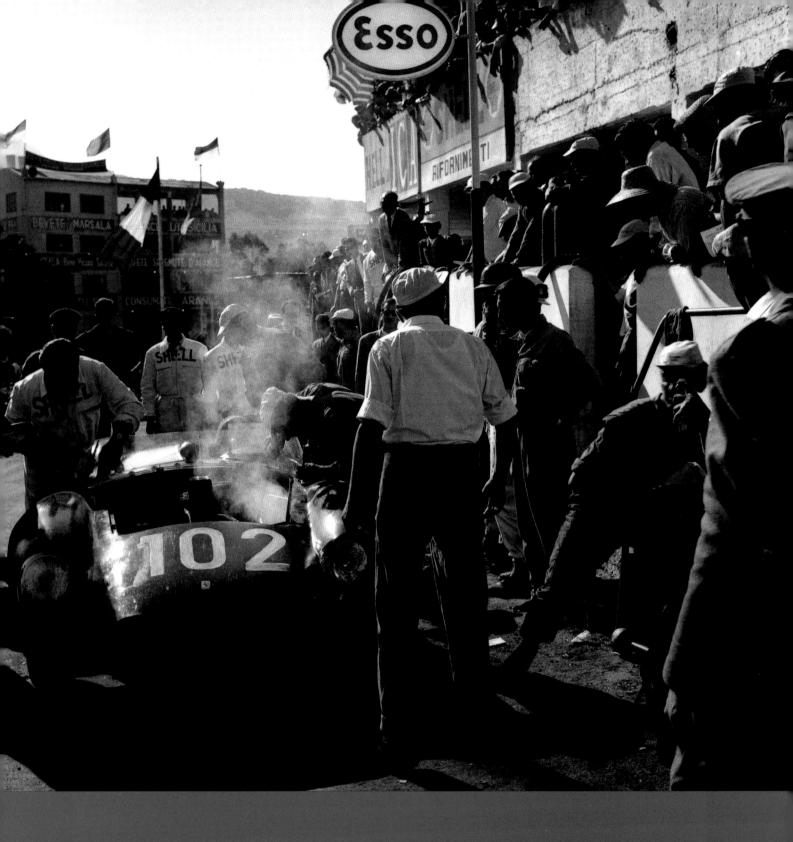

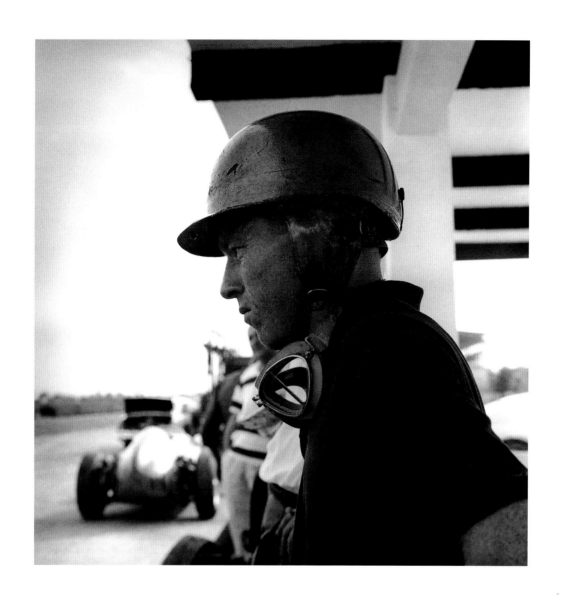

19
59

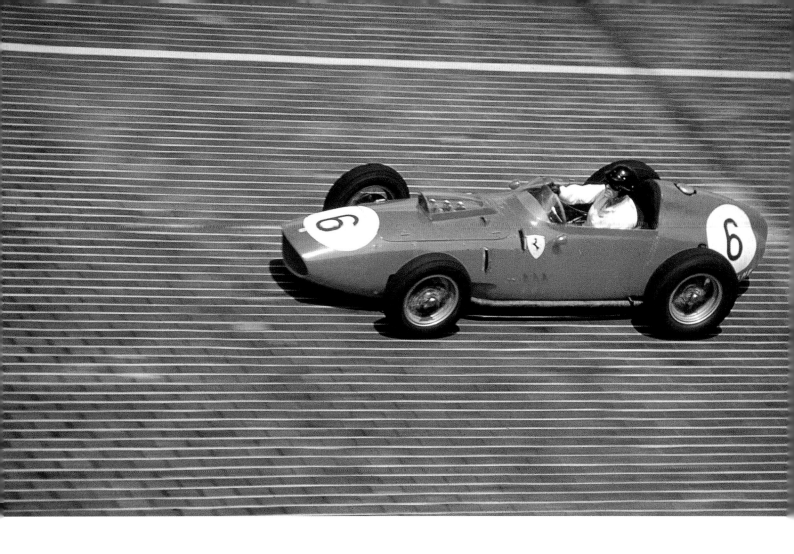

PLATE **68**

PLATE **69**

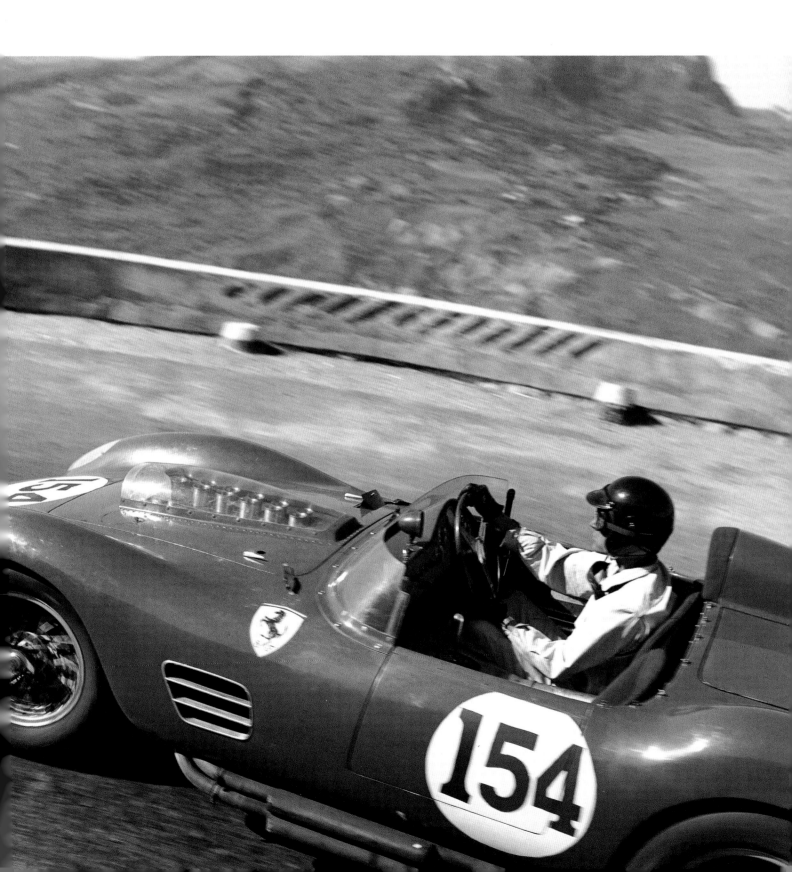

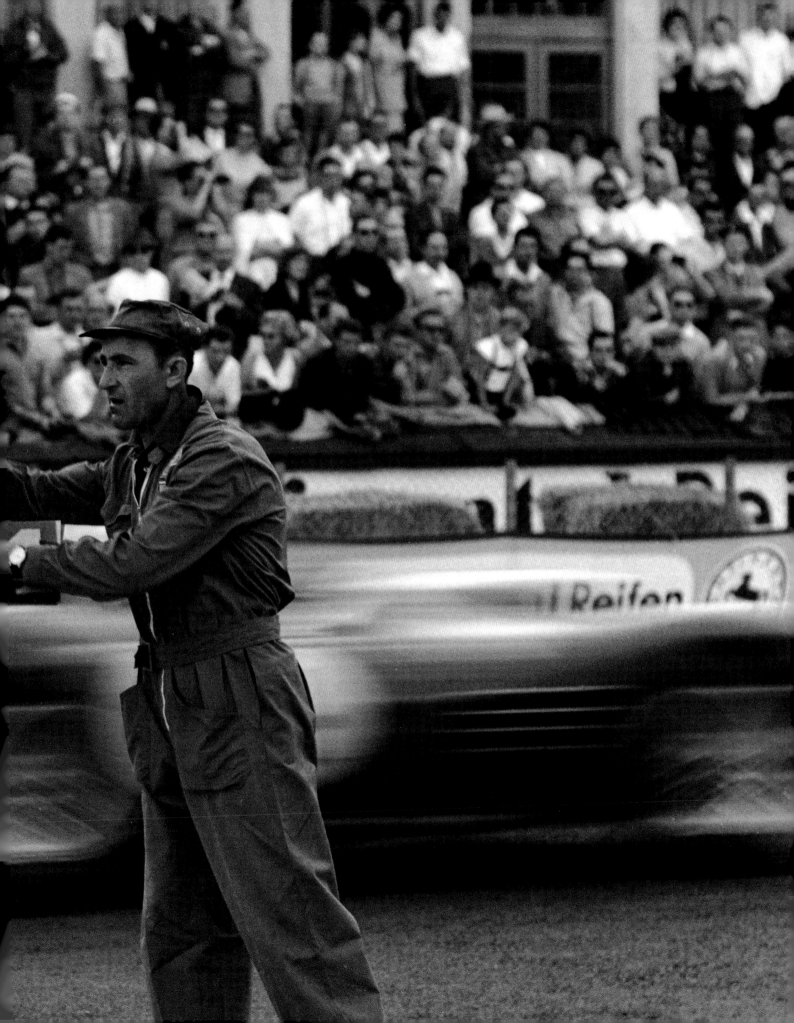

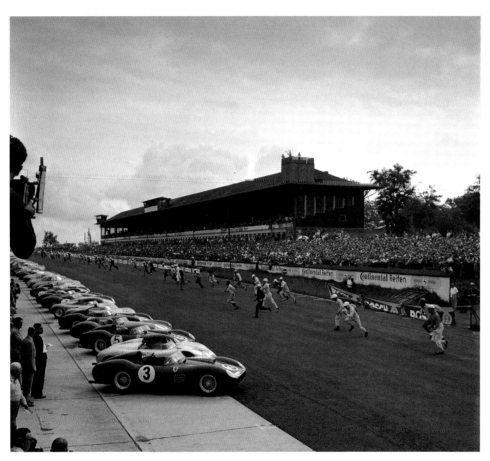

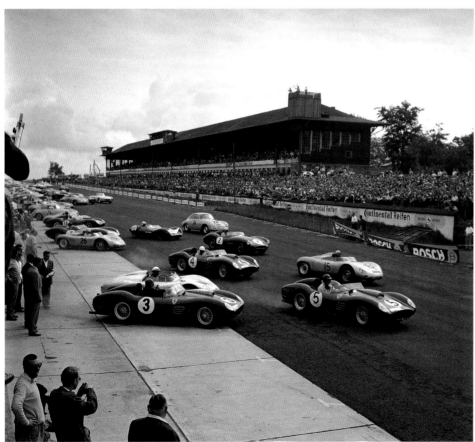

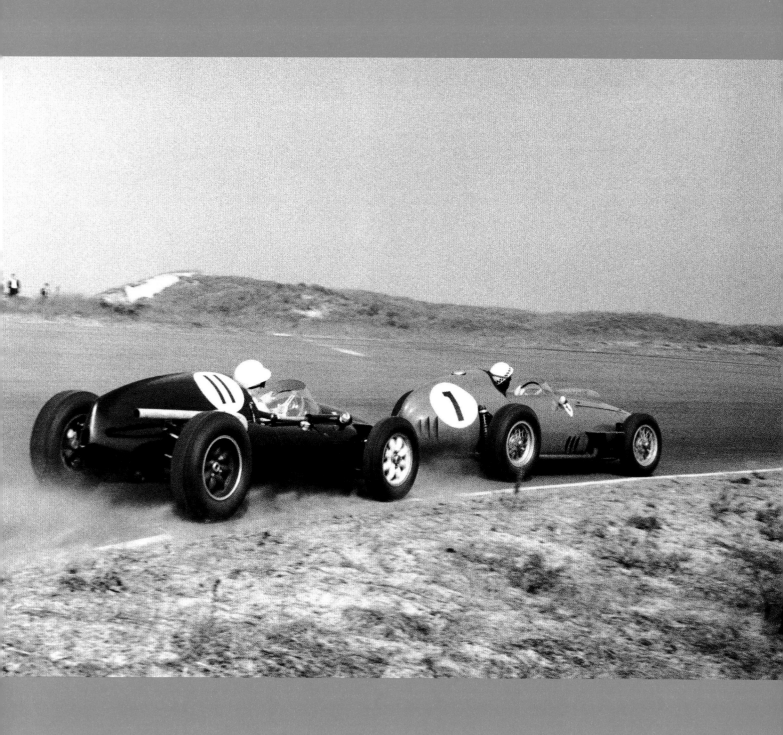

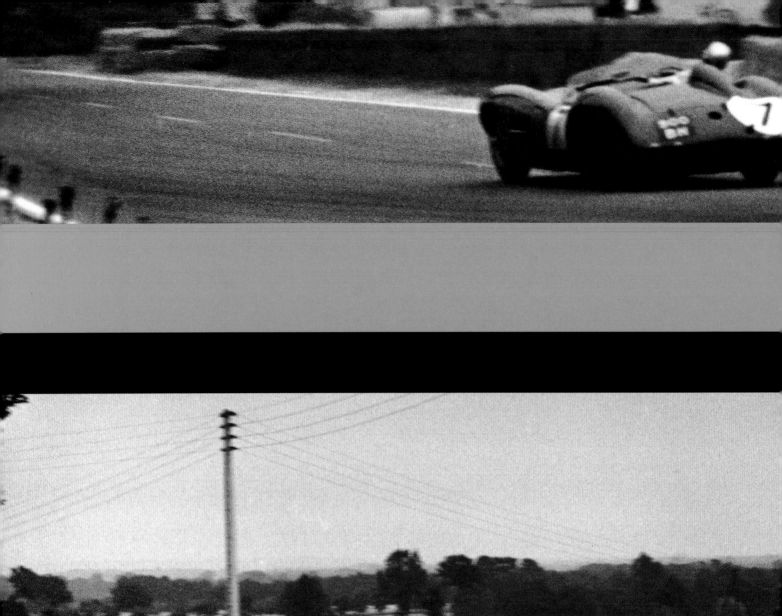
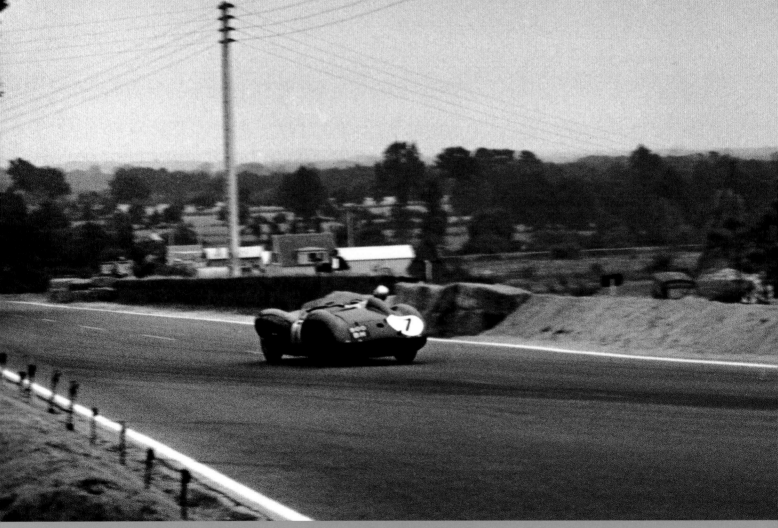

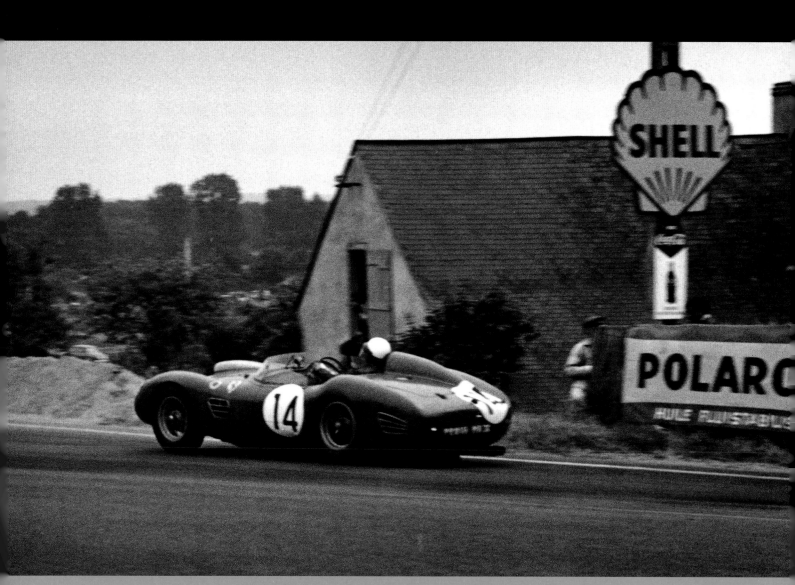

PLATE **74**

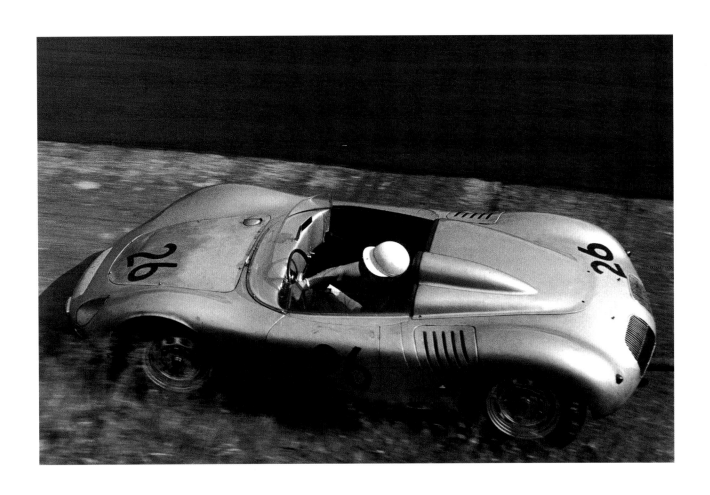

PLATE **75**

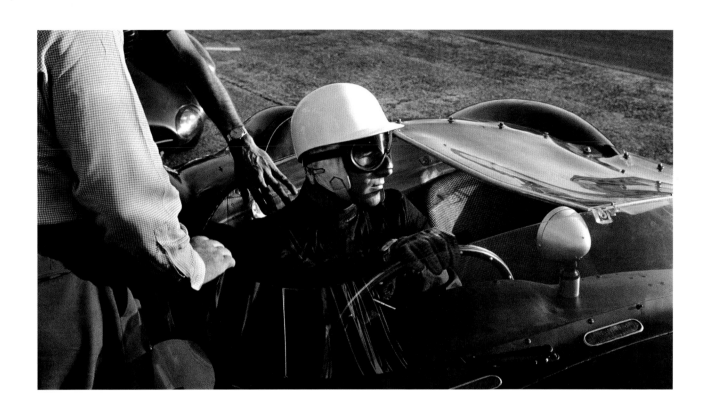

PLATE **76**

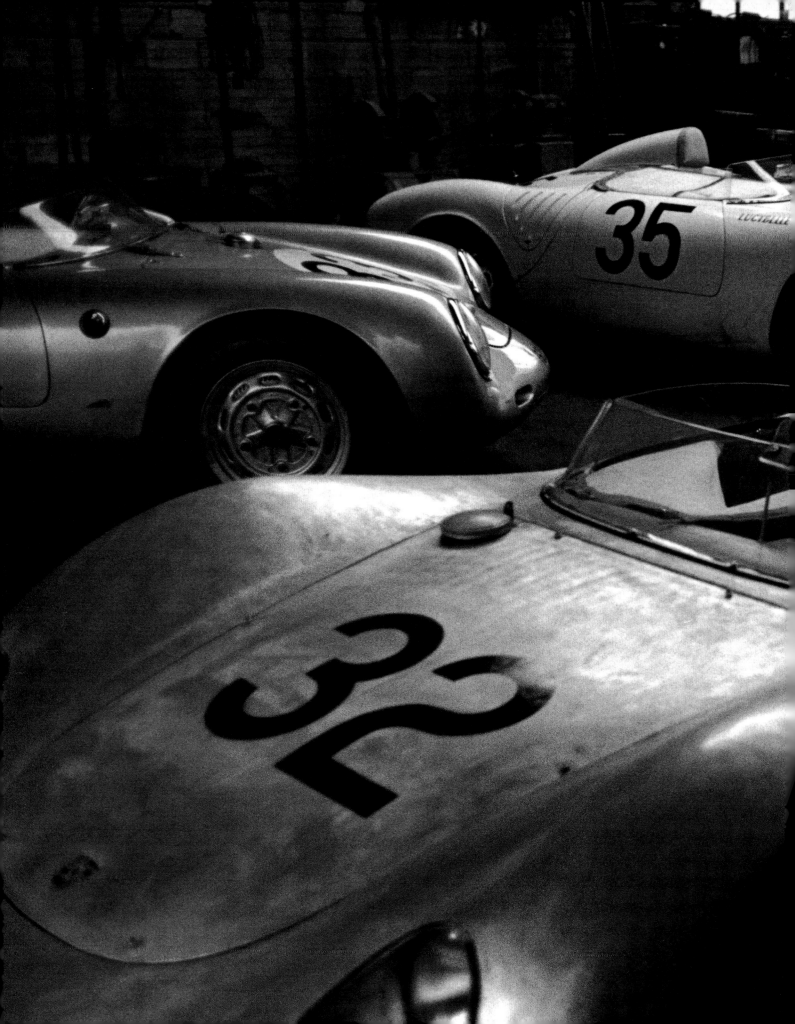

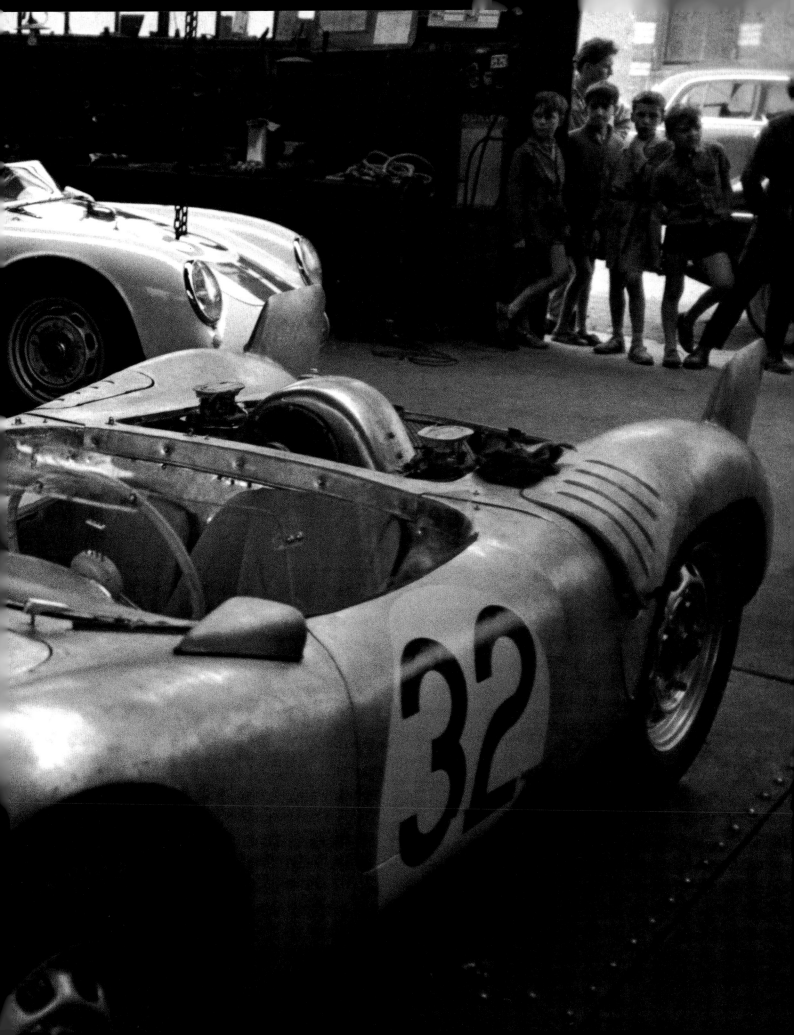

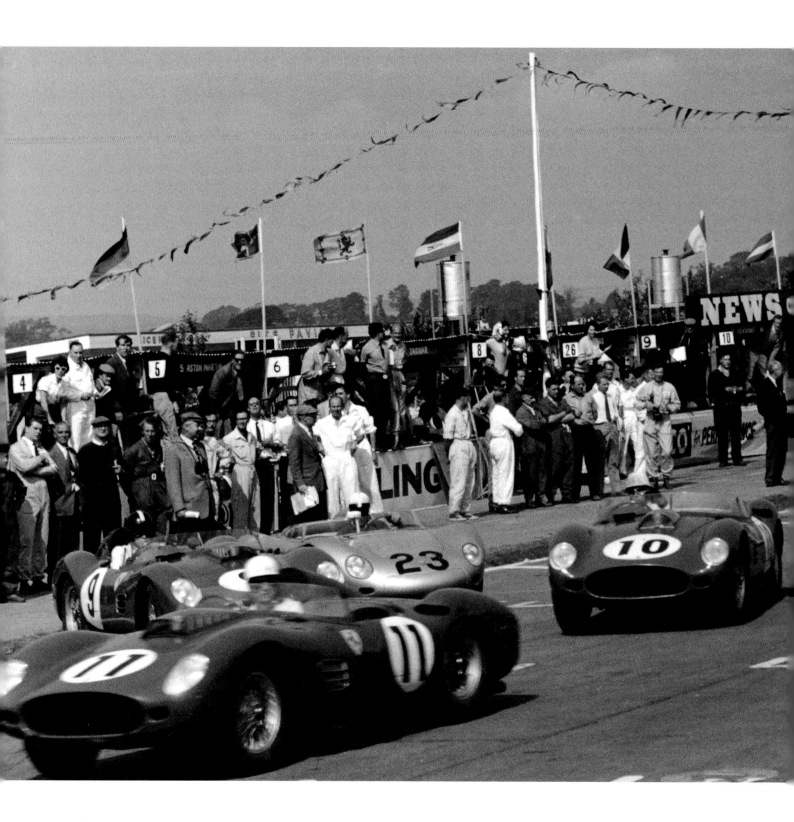

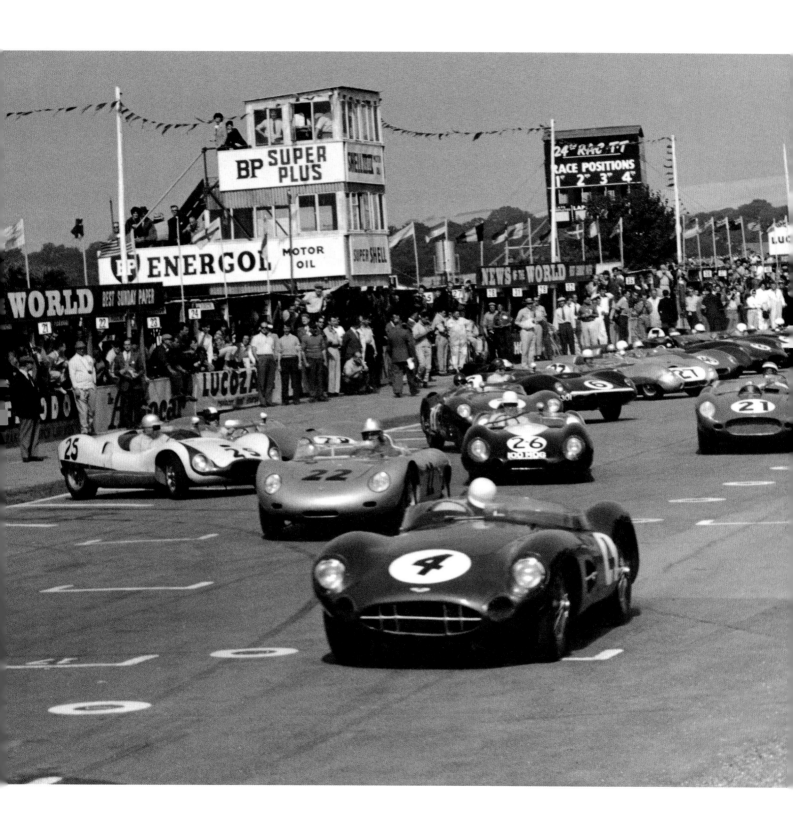

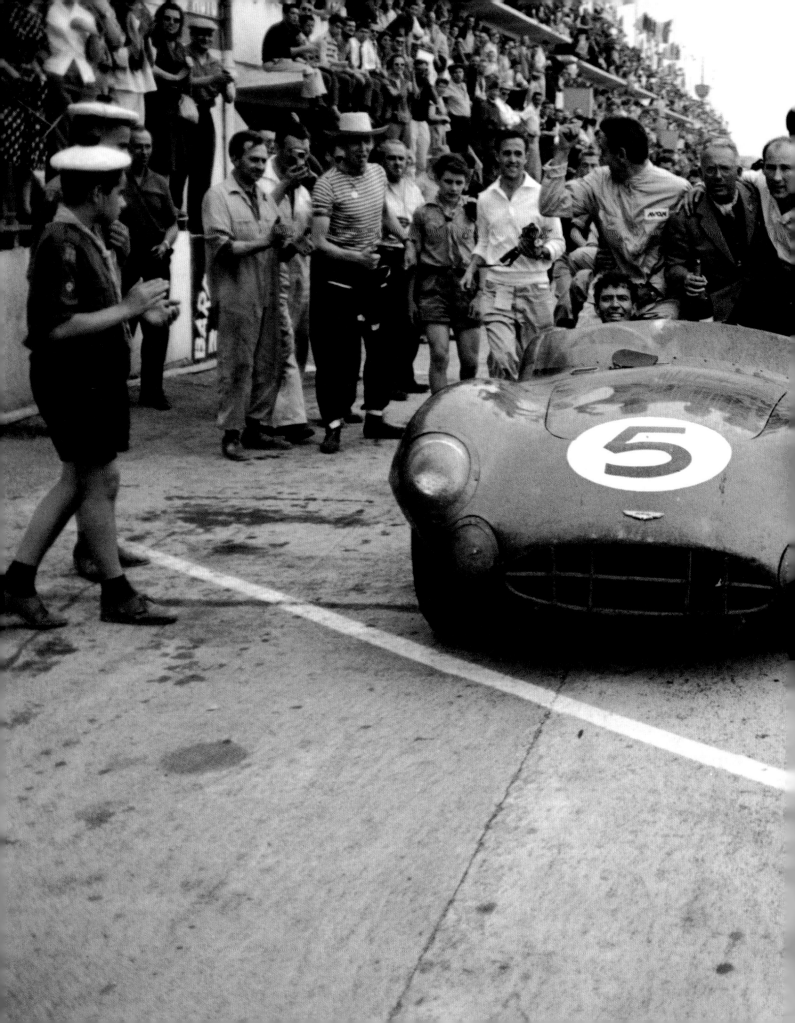

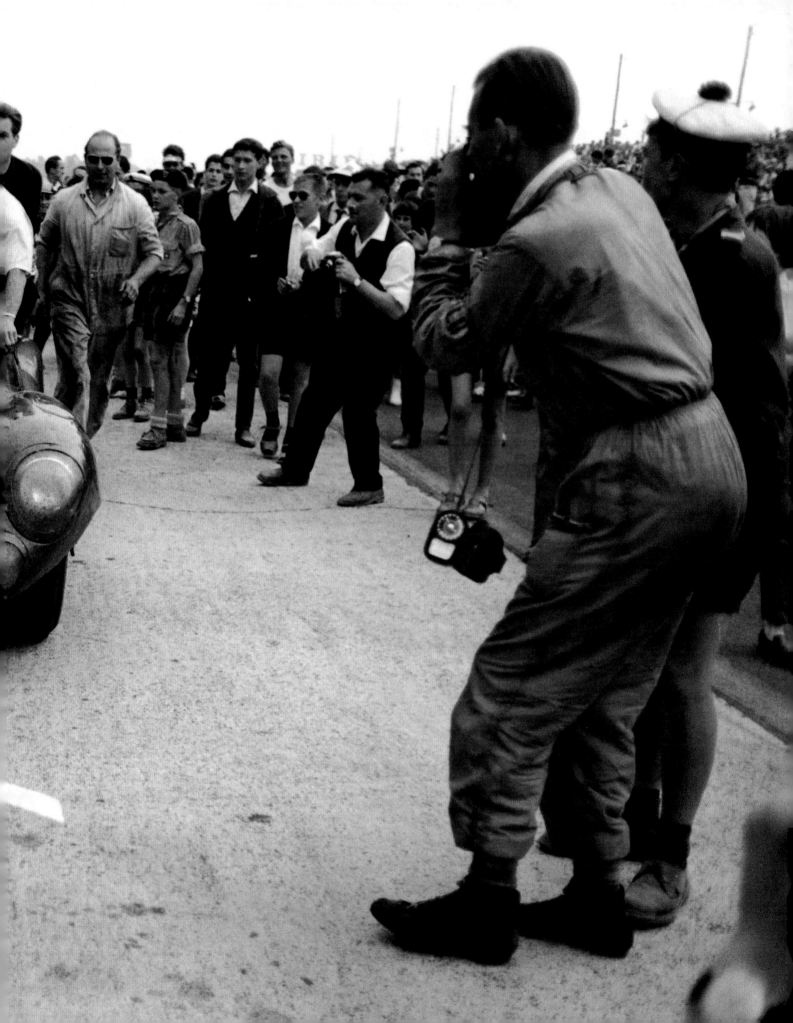

PREVIOUS SPREAD: PLATE **79** ----- ABOVE: PLATE **80** ----- RIGHT: PLATE **81**

19
60

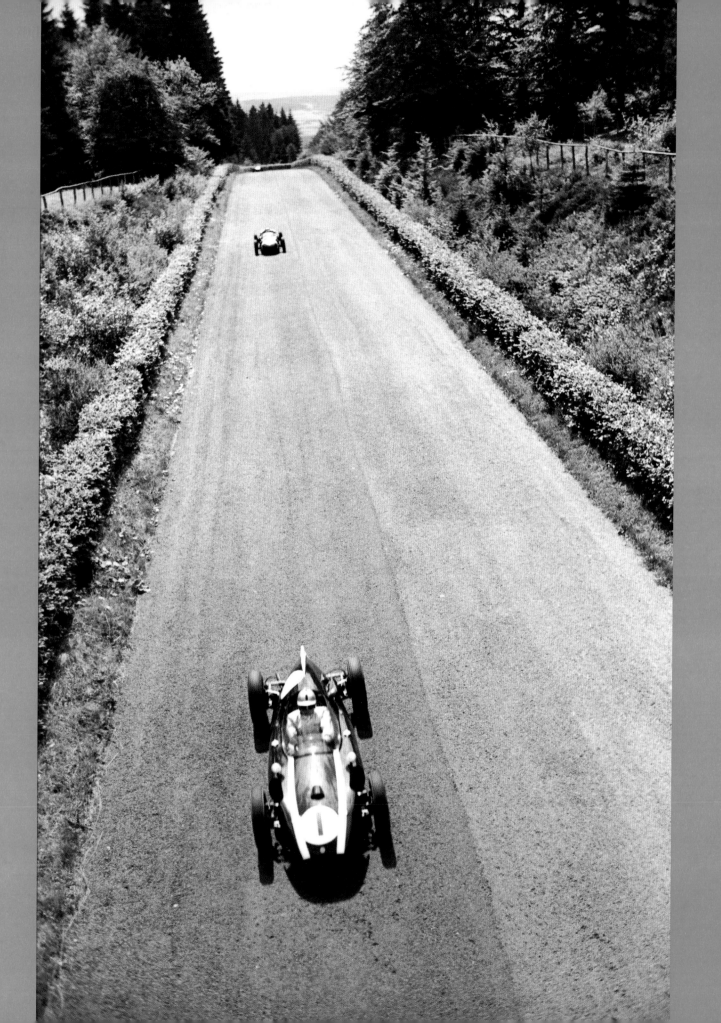

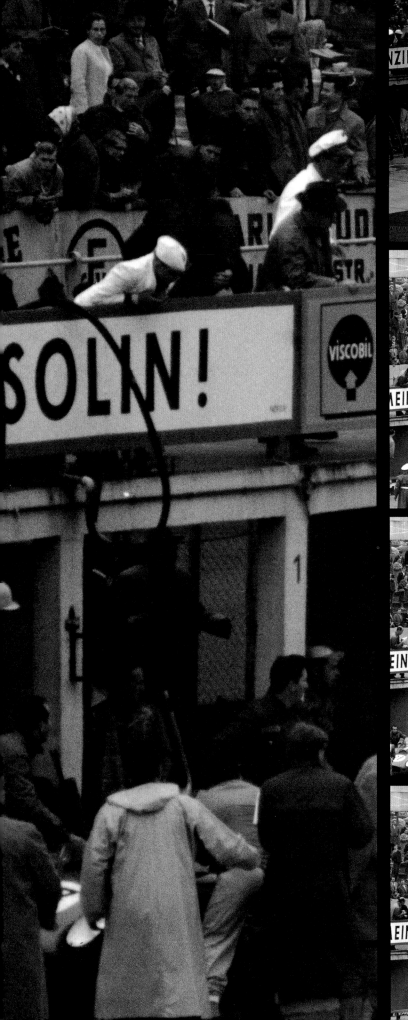
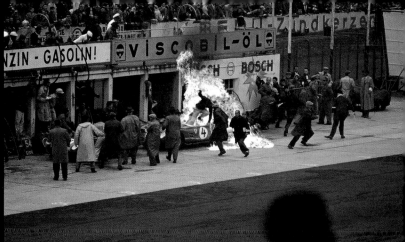
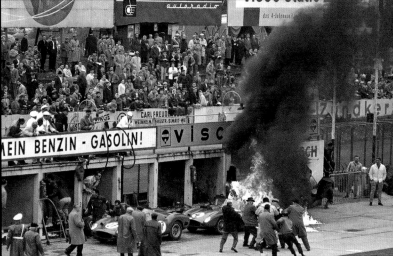
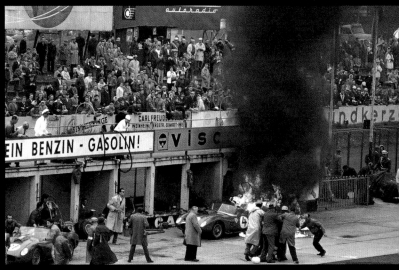
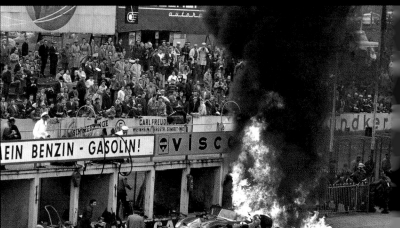

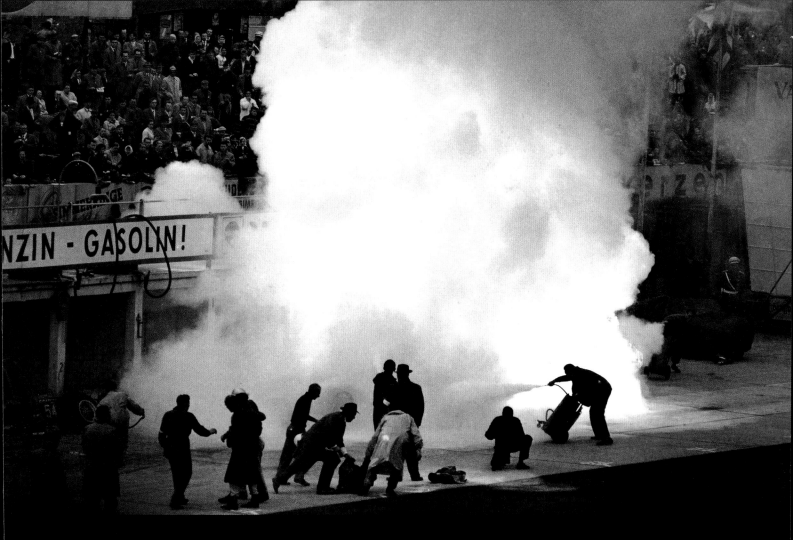

1
PLATE 82

2
PLATE 83

3
PLATE 84

4
PLATE 85

5
PLATE 86

SEQUENCE

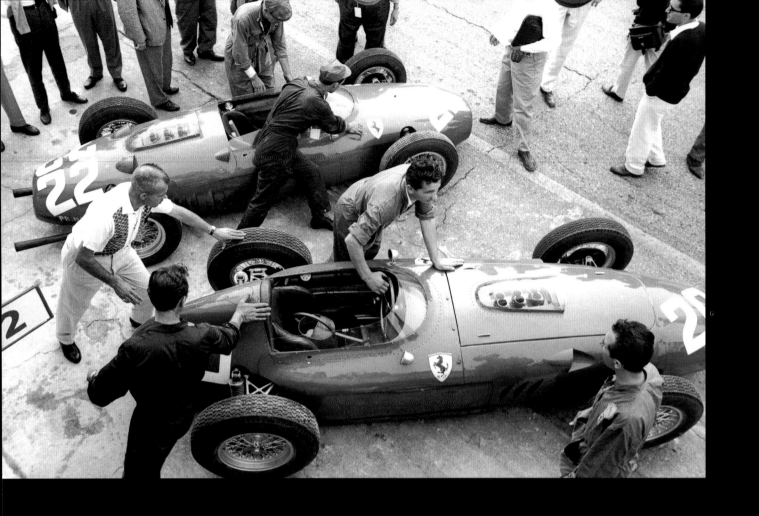

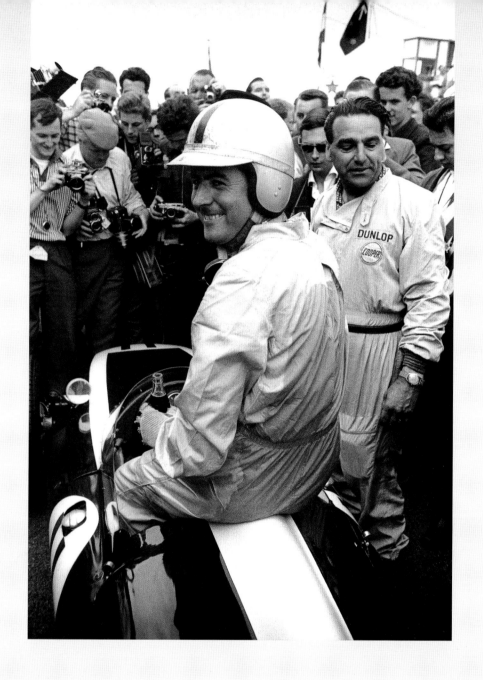

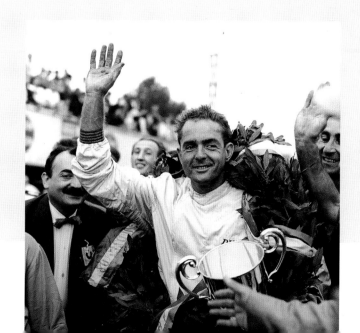

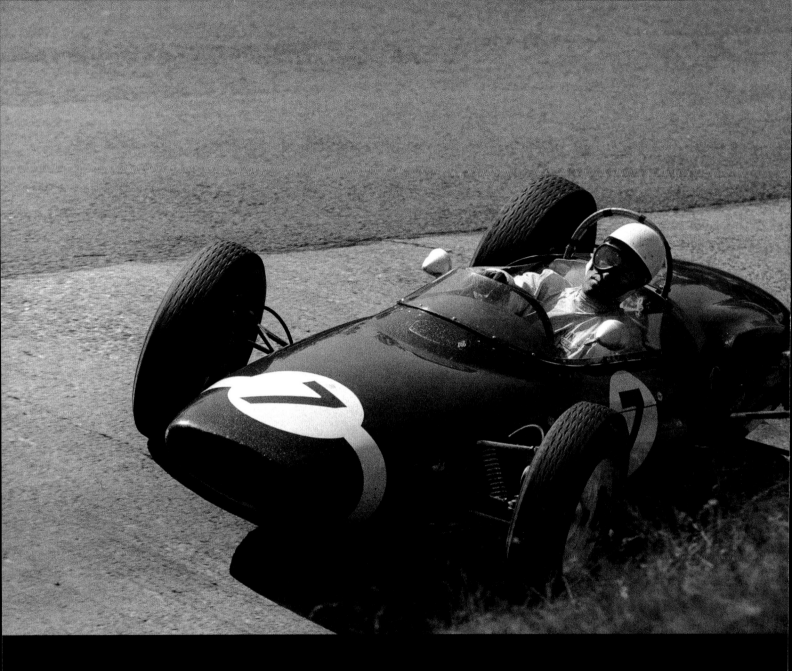

19
61

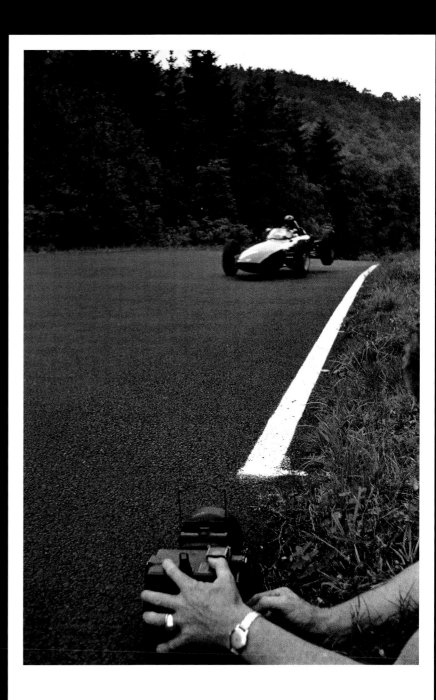

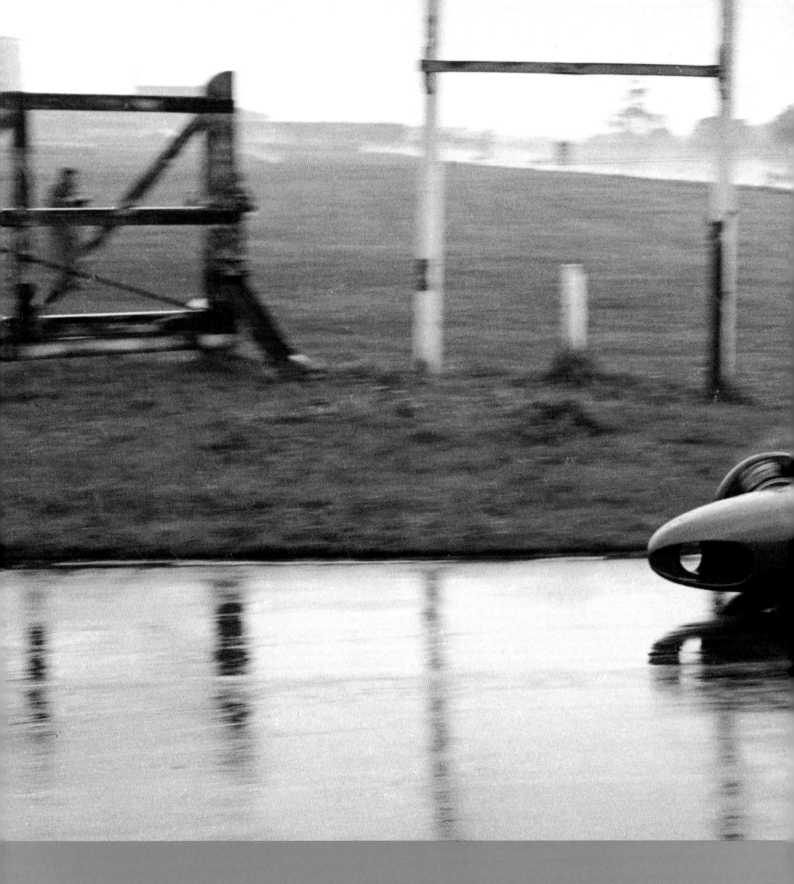

PLATE **92**

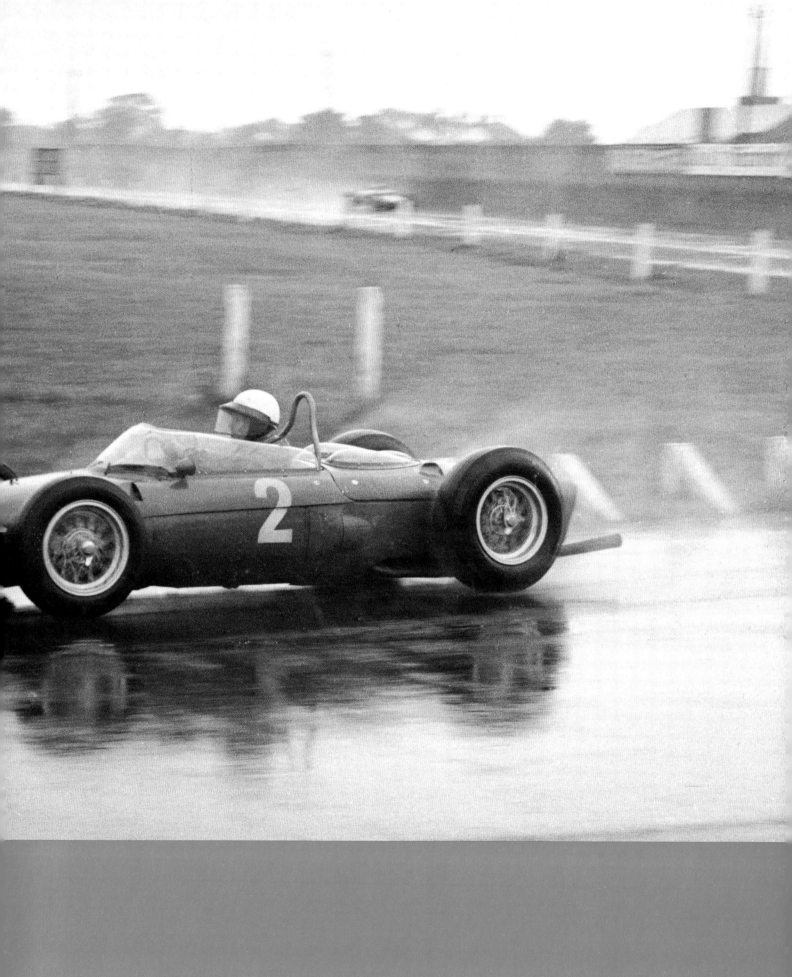

19
62

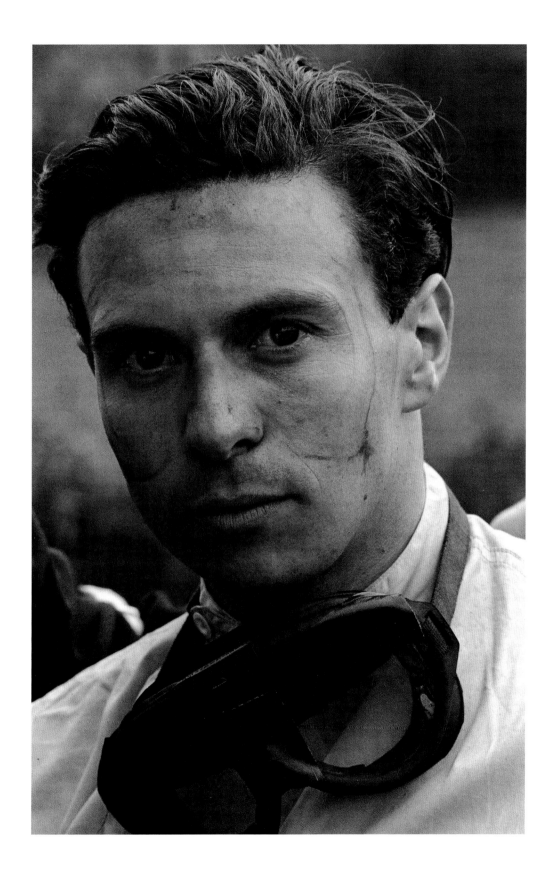

PLATE **93**

FOLLOWING SPREAD: PLATE **94**

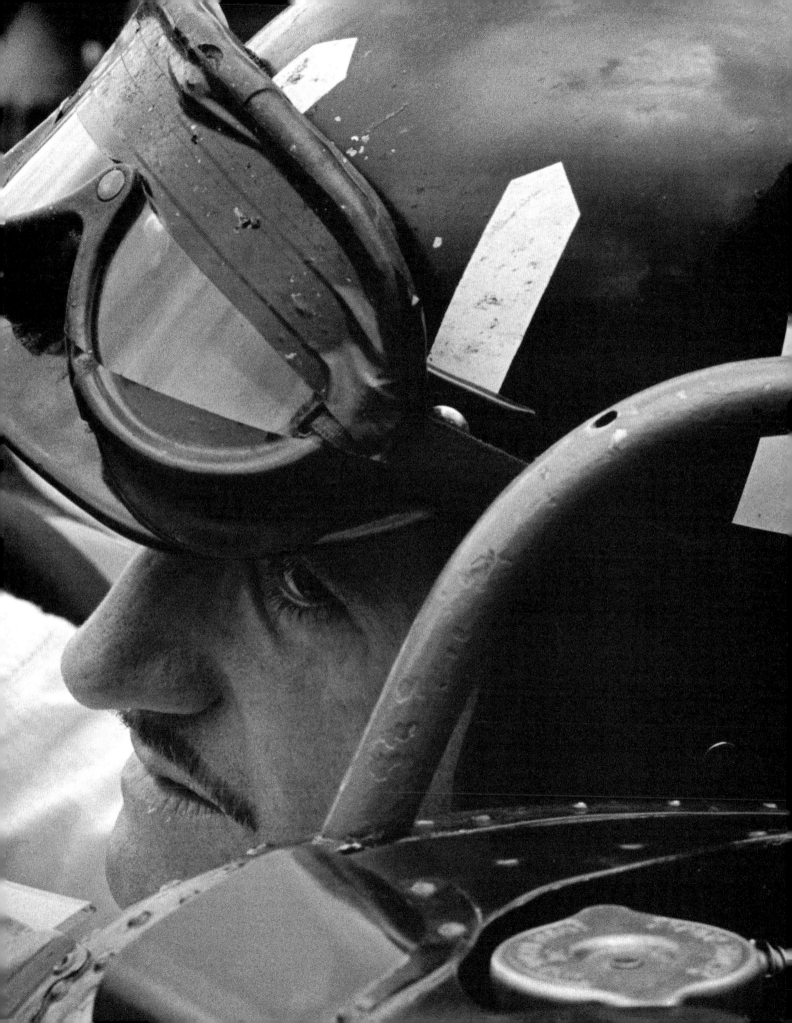

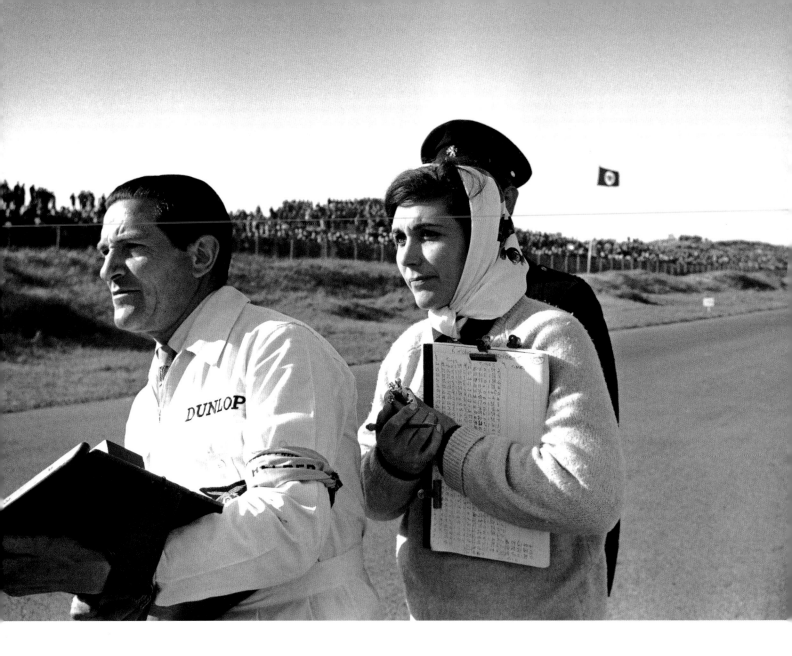

SEQUENCE

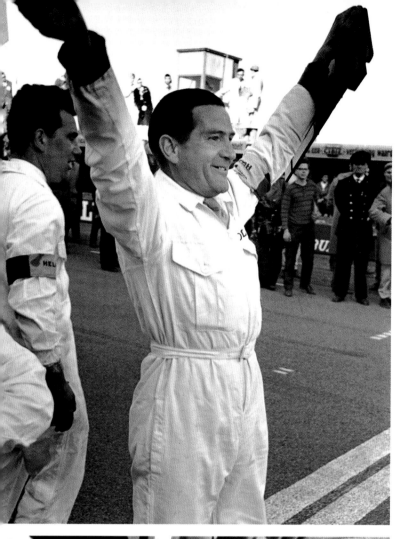
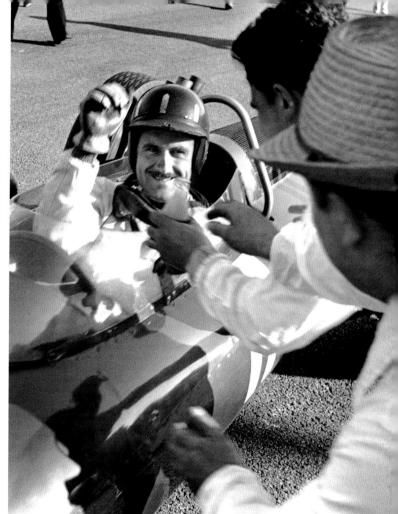
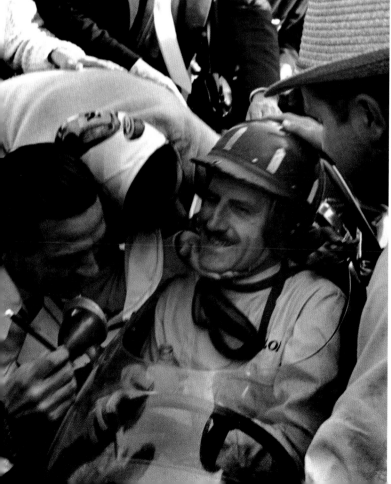

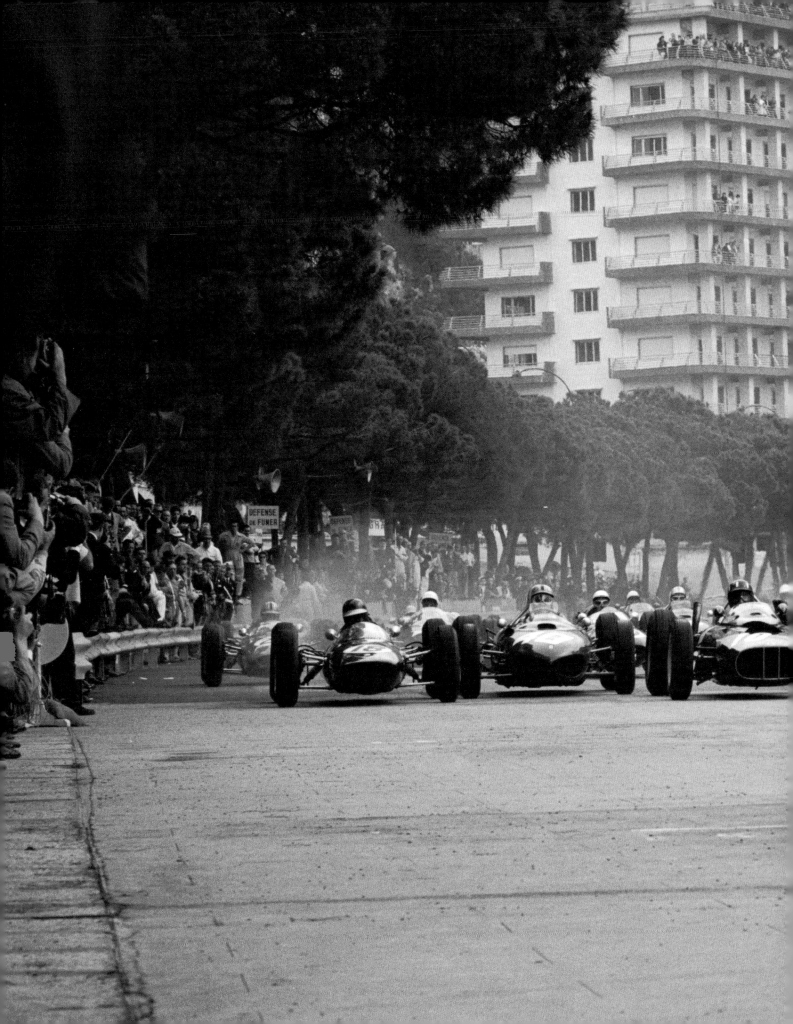

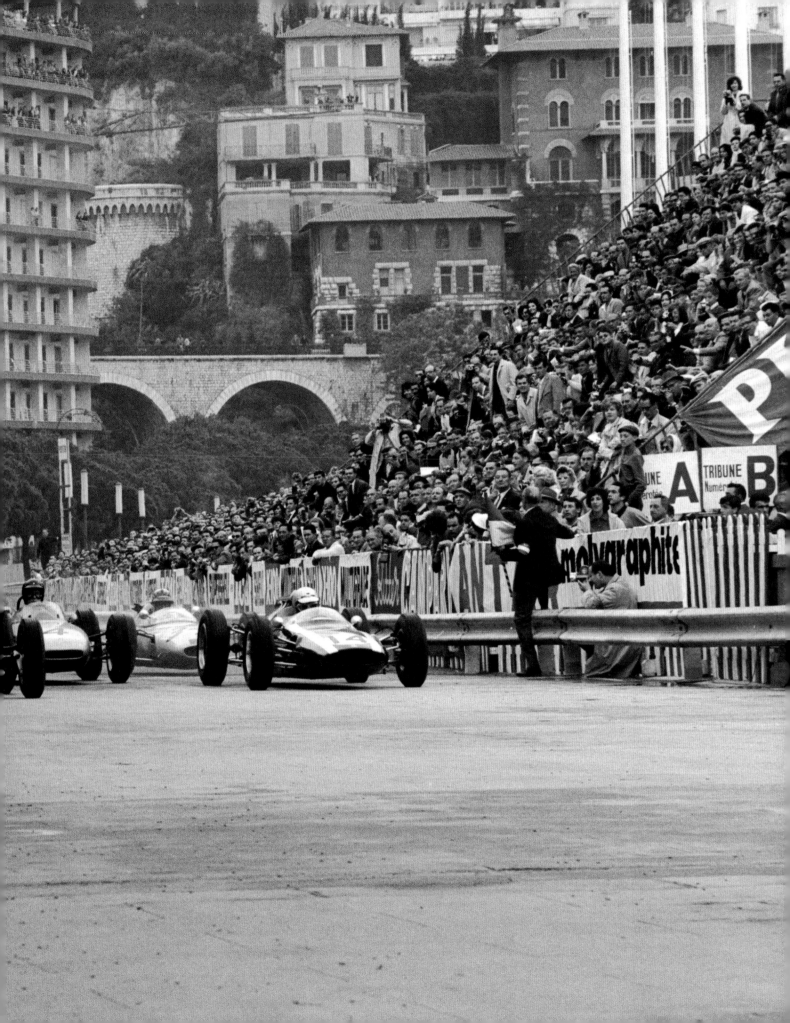

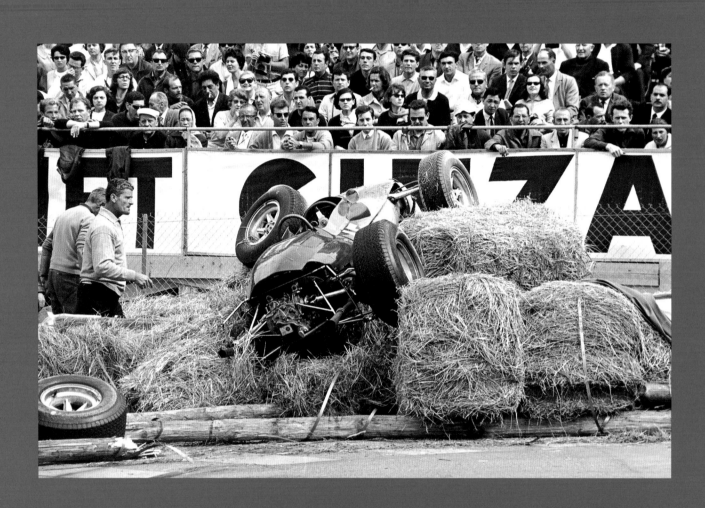

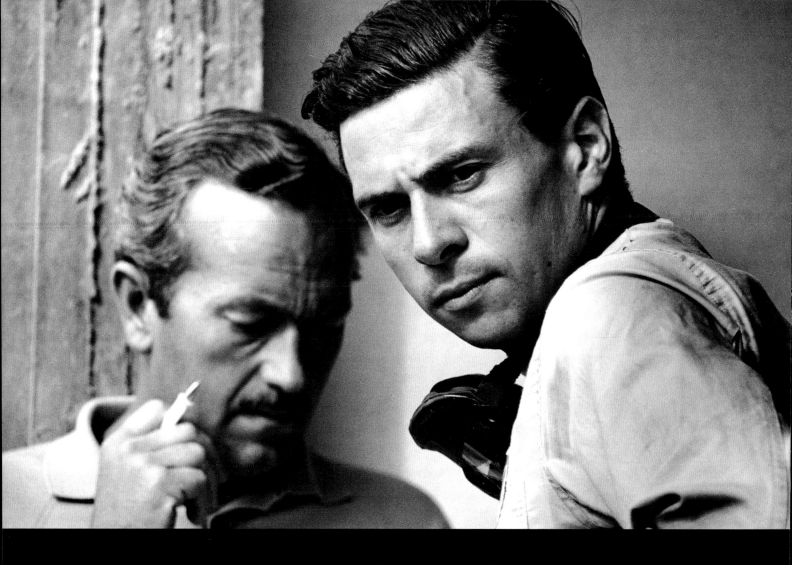
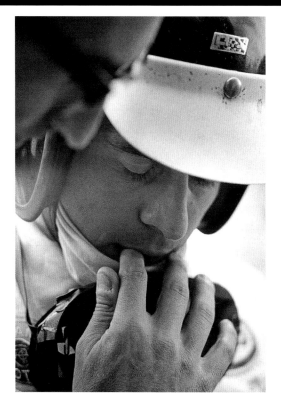

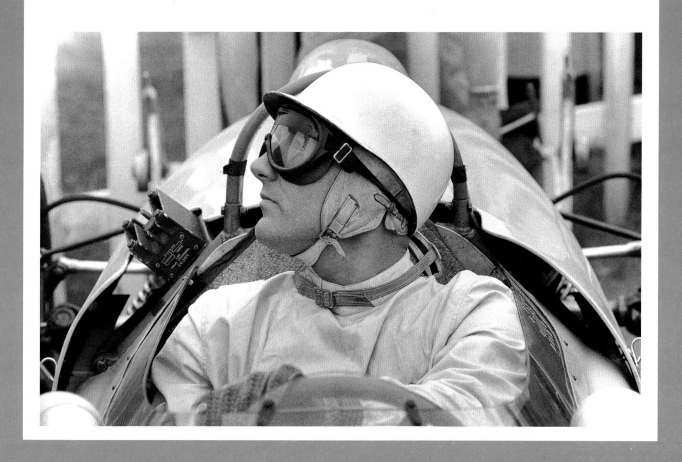

TOP LEFT: PLATE **104** ----- BOTTOM LEFT: PLATE **105** ----- ABOVE: PLATE **106** ----- BELOW: PLATE **107**

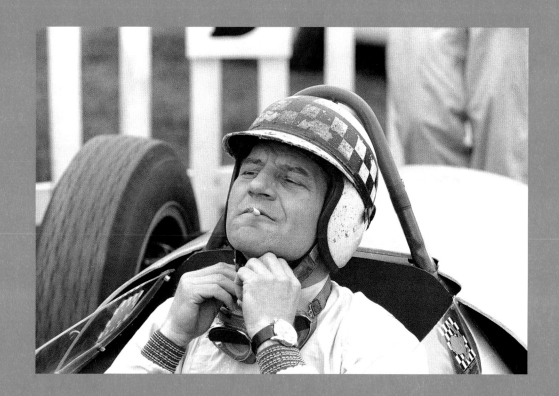

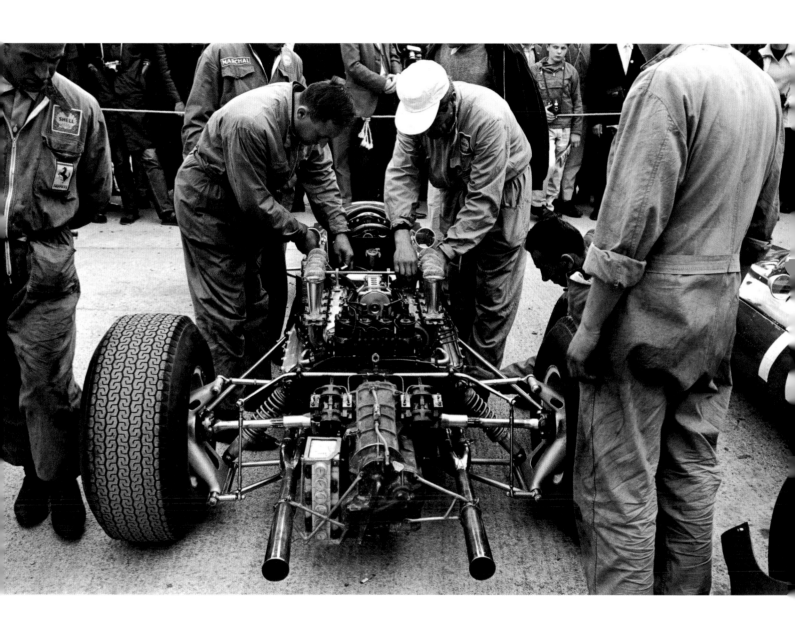

PLATE **108**

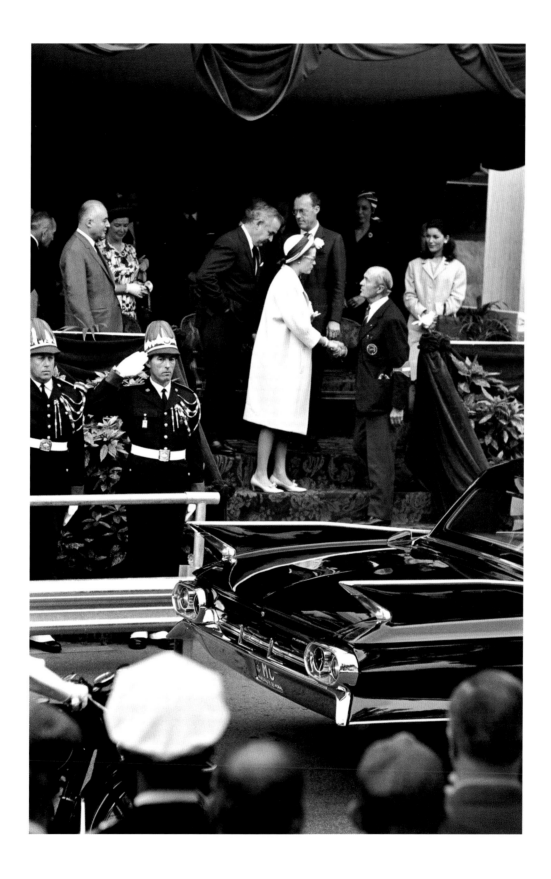

PLATE **109**

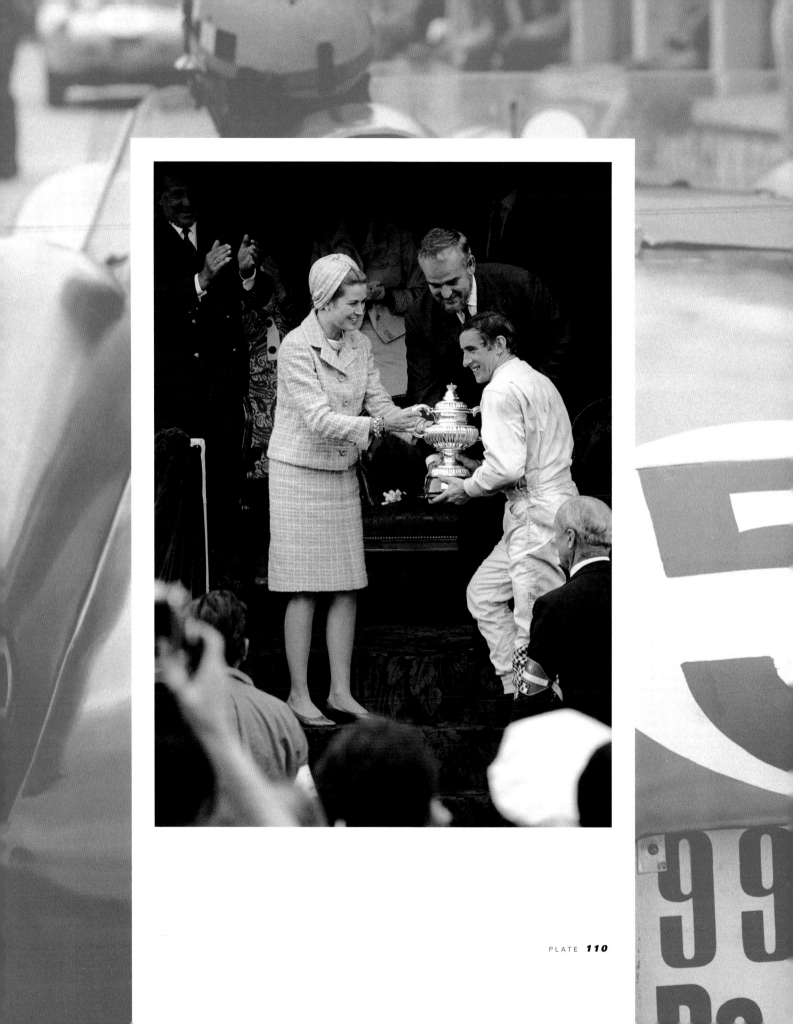

PLATE **110**

CAPTIONS

→

JIM CLARK, WORLD CHAMPION FROM SCOTLAND.

— — — — — — PLATE 1

Sitting in his Lotus Formula One car, he impatiently waits for the mechanics to finish their work and the race to start. Seat belts of any kind are absent from the cockpit, and he wears the lightweight racing suit as well as string-backed leather gloves that have become fashionable today with historic race car enthusiasts.

GRAND PRIX OF PAU, APRIL 1955.

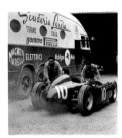

— — — — — — PLATE 2

The Lancia mechanics push Eugenio Castellotti's D50 Formula One car towards the paddock prior to practice for one of the first races of the season. Pau, a large city in southwest France, is one of the few European venues where, like Monaco, races were held on city streets. The Lancia debuted in late 1954, but its success was limited. By the time the car was competitive, the competition from Mercedes and Maserati was overwhelming. Lancia also had major financial difficulties. In early 1955 Ferrari took possession of the team.

GRAND PRIX OF ITALY, MONZA, 1958.

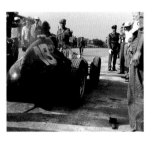

— — — — — — PLATE 3

The Ferrari Formula One car is started by means of a portable electric starter, which the mechanic inserts into the drive train of the car from the rear. The picture was taken during a pit stop that included a tire change. Note the small hammer used on the knock-off wheels, which the mechanic has hastily tossed aside. Ferrari pit stops were always exciting but notoriously frantic and often somewhat disorganized. Note that there are a number of policemen hanging about.

SPA-FRANCORCHAMPS, GRAND PRIX OF BELGIUM, JUNE 1955.

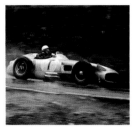

— — — — — — PLATE 4

The Mercedes W196 of Stirling Moss practices in the rain on one of the fastest road racing circuits in Europe. Moss teamed with the Argentine champion, Juan Manuel Fangio, as the two drivers spearheaded the Mercedes effort in 1955, dominating the season. This is the open-wheeled version of the W196, a car that Mercedes uses today at historic events around the world to promote its racing heritage.

LA CARRERA PANAMERICANA, NOVEMBER 1953.

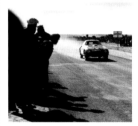

— — — — — — PLATE 5

In Juarez, the Ferrari 375MM of Umberto Maglioli crosses the line. Spectator control was minimal, and serious accidents were frequent. On a par with Italy's Mille Miglia and Targa Florio, the last Carrera was held in 1954. By 1957 the death toll of bystanders had risen dramatically following the accident of de Portago's Ferrari in the Mille Miglia in which ten spectators were killed. The Italian authorities said "no more" and open road racing was banned.

SOMEWHERE NORTH OF MEXICO CITY, LA CARRERA PANAMERICANA, 1953.

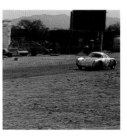

— — — — — — PLATE 6

The Porsche driven by Jaroslav Juhan is headed north towards Ciudad Juarez. This was the famous Mexican Road Race. The venue was the beginning of a Porsche racing program that used long-distance sports car racing as a marketing tool for production cars. Interesting is the fact that the design of this race car strongly influenced the designer of the Audi TT, Freeman Thomas, almost fifty years later.

STIRLING MOSS, GRAND PRIX OF ITALY, MONZA, 1957.

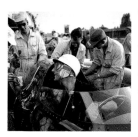

– – – – – – PLATE 7

Moss jokes with his mechanic while the race number is painted on the rear of the Vanwall. Note the attractive shape of the curved wind screen and the aerodynamic line of the Costin-designed Vanwall body. Moss won at Monza but with only forty seconds between him and World Champion Juan Fangio.

MERCEDES W196, GRAND PRIX OF FRANCE, REIMS, 1954.

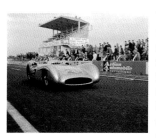

– – – – – – PLATE 8

Karl Kling at speed on the main straight at Reims. This was the fastest circuit in Europe, and Mercedes arrived with an aerodynamic, fully enclosed body that gave them a distinct advantage over both Ferrari and Maserati, their chief competitors. The result was a decisive victory for Fangio, with Kling second, Herrmann having retired with engine trouble.

GRAND PRIX OF FRANCE, REIMS, JULY 1954.

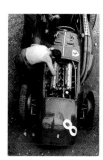

– – – – – – PLATE 9

The overhead view was taken in the paddock behind the pits during practice for the Grand Prix. The mechanic works on the engine of the Ferrari 553, a 2.5-litre four-cylinder that proved to be no match for the revolutionary Mercedes W196, a model that debuted at Reims that year. It featured inboard drum brakes and mechanically operated valves.

MERCEDES W196 IN THE PADDOCK, GRAND PRIX OF FRANCE, 1954.

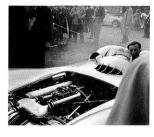

– – – – – – PLATE 10

In July 1954 Mercedes-Benz returned after an absence of fifteen years to racing with the revolutionary W196 Formula One car. The photograph was taken in the paddock prior to practice while the mechanic warms up the engine, a fuel-injected straight eight featuring mechanically operated desmodromic valves. The two large circular objects at the front of the engine are inboard drum brakes. The Mercedes debut was a major event in Formula One history books. Driven by Juan Fangio, this streamlined version of the W196 handily won the French race, while the open-wheel version still to come proved to be more suitable for slower, tighter circuits.

ENZO FERRARI AND GIORGIO SCARLATTI, MODENA, MID-1950S.

– – – – – – PLATE 11

The Roman driver Scarlatti drove primarily sports cars for Ferrari and also had driven for Maserati. The scene here is in the pits at the Modena track, where testing was done until a much larger facility was built closer to the Ferrari factory.

SPECTATORS AT MONACO, MID-1950S.

– – – – – – PLATE 12

The Grand Prix scene has always been and always will be a magnet for young women eager to see their heroes in action.

GRAND PRIX OF PAU, FRANCE, APRIL 1955.

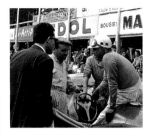

----- PLATE 13

The pits at Pau had a small-town atmosphere with the locals allowed in during practice. Luigi Musso's works Maserati 250F is the center of attention. Head mechanic Guerino Bertocchi confers with his driver. Besides the factory Maseratis, several privately entered cars made up the starting grid. Pau was considered a preliminary race of the season, along with Turin, Bordeaux, and Syracuse, Sicily. These events did not offer world championship points but did allow manufacturers a venue to further try out their cars for the coming season.

BELGIAN GRAND PRIX, SPA/FRANCORCHAMPS, 1955.

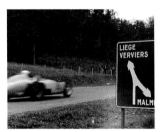

----- PLATE 14

The legendary Belgian racing circuit known as "Spa" is situated in the heart of the Ardennes mountains near the border with Germany. During its heyday the track was considered one of the fastest and most dangerous in Europe, vying only with Reims, the French circuit, for the honor of being the fastest. The Mercedes is passing the turn for Malmedy and will continue at maximum speed down the famous Masta straight.

MASERATI 250F FORMULA ONE CARS, PAU, 1955.

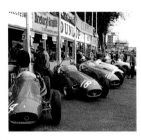

----- PLATE 15

Lined up in the pits at Pau are five 250F machines, considered to be the most beautiful racers of the period. The three in the foreground are factory racers while the others are private entrants. Today the 250F Maserati is a highly valued vintage racer. The most valuable are cars that can be identified as former Fangio, Moss, or Behra machines. At today's auctions such a car could easily command over a million dollars.

ALBERTO ASCARI, LANCIA D50, GRAND PRIX OF PAU, 1955.

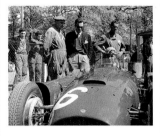

----- PLATE 16

The Lancia D50 appeared in late 1954 and was noted for its four-cam V8 engine and large fuel tanks on either side of the driver. Alberto Ascari was lead driver for the team, comprising not only Ascari but Luigi Villoresi and Eugenio Castellotti. At the time Lancia hoped to challenge both Ferrari and Maserati for Formula One honors, but the team lacked the financial means. Additionally, by 1955 the Mercedes-Benz juggernaut was back, and with Fangio and Moss, the Stuttgart team was unbeatable.

ALBERTO ASCARI, LANCIA D50, GRAND PRIX OF PAU, 1955.

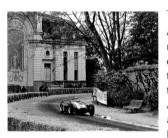

----- PLATE 17

Ascari's Lancia is seen here rounding a curve at the entrance to a large park in the heart of town. This was to be Ascari's last season. After suffering a horrendous accident at Monaco when his Lancia plunged into the harbor during the Grand Prix, he was killed three days later while testing a Ferrari sports car at Monza. News reports of the day say that he was wearing a borrowed helmet. Ascari had been World Champion in 1952 and 1953 and was considered Fangio's primary rival.

MERCEDES W196, GRAND PRIX OF ITALY, MONZA, 1955.

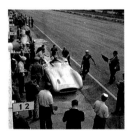

----- PLATE 18

The fully enclosed body of the W196 is clearly shown in this photograph, which was taken from the balcony overlooking the pits. Behind the wheel is Juan Manuel Fangio, World Champion from Argentina. At the right, wielding the flag, is Alfred Neubauer, the Mercedes team manager. The scene is during practice as the mechanics and engineers try to solve many problems associated with the Monza track, which at that time included a high speed banking. Its rough surface and higher speeds were a big challenge for all competitors.

GRAND PRIX OF MONACO, 1955.

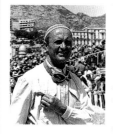

— — — — — PLATE 19

Monagasque Louis Chiron is on the starting grid at the age of fifty-six. He is about to get behind the wheel of his Lancia D50 alongside his teammates Ascari, Castellotti, and Villoresi. Ascari crashed at the chicane and went into the harbor while Villoresi retired. Castellotti came in second and Chiron finished sixth. He began his career in 1923 and drove for Bugatti, Mercedes, and Alfa Romeo during the pre-war years. His biggest win was with Alfa at Reims in 1934 when he surprised everyone by beating the all-powerful Mercedes. After his retirement, Chiron ran the Monaco Grand Prix and was the clerk of the course for many years.

STIRLING MOSS, GRAND PRIX OF BELGIUM, SPA, 1955.

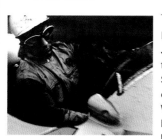

— — — — — PLATE 20

For 1955 Stirling Moss joined Juan Fangio on the Mercedes team. Here he is seen at "La Source" corner driving the open-wheel version of the W196. The picture was taken late in the race as the 500-kilometer distance at Spa has turned into a Mercedes walkover. Moss finished second just eight seconds behind Fangio, the latter's average speed being almost 120 mph. Race reports of the day describe the event as monotonous, with Fangio and Moss in the lead for the full thirty-six-lap distance. This was a momentous year for Moss, despite the fact that he was forced to play number two to Fangio. Stirling's incredible victory in the Mille Miglia sports car race and his Grand Prix win on home ground at Aintree were the high points that linked his name with Mercedes for the rest of his career.

GRAND PRIX OF ITALY, MONZA, 1955.

— — — — — PLATE 21

Mercedes-Benz team manager Neubauer signals Juan Fangio during the Italian Grand Prix. This was to be the last Grand Prix for Alfred Neubauer, who had led Mercedes racing efforts since 1926. He had been a motorsports enthusiast in his youth and actually raced for Mercedes in the 1924 Targa Florio when he was working at Mercedes as a designer. By 1926 he was appointed team manager. When Hitler decided that motor racing would be a strong advertisement for the success of National Socialism, German Grand Prix racing began again in earnest in 1934. The record books show that Mercedes had thirty-four Grand Prix wins under Neubauer.

STIRLING MOSS AND DENIS JENKINSON, MILLE MIGLIA, 1955.

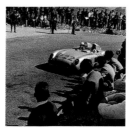

— — — — — PLATE 22

Motor racing history was made this first day of May in 1955. Moss with "Jenks" acting as his navigator drove their factory-entered Mercedes 300SLR to a legendary victory in the twenty-second running of the Mille Miglia. The 1000-mile road race was held on Italy's public roads. Starting in the north at Brescia, the route took the competitors east to the Adriatic coast, then south as far as Pescara, then sharp right over the mountains to Rome. From the capital they headed in the direction of Siena and Florence, then over the mountains to Bologna and on across the Po Valley back to Brescia, all in the space of ten hours at an average speed of almost 99 mph.

MILLE MIGLIA, 1955.

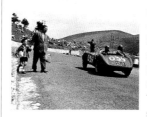

— — — — — PLATE 23

Italy's legendary Mille Miglia was open to a wide variety of cars, including smaller and slower models. This Stanguellini driven by Annamaria Peduzzi started the race 39 minutes after midnight. Twelve hours later she was struggling up the Raticosa Pass approaching Bologna. The race was a major event in the lives of all Italians passionate about motorsports. The day of the race was like a national holiday along the entire 1000-mile route.

RALLYE MONTE CARLO, FRANCE, 1956.

— — — — — PLATE 24

In the 1950s the European Rally Championship was a major spectator event, and the Monte Carlo Rally, if not the most difficult, was the most glamorous. Entrants started from various major cities in Europe with Monte Carlo as the final destination. In this image a DKW is passing through a French village in the mountains near Monaco during a special stage requiring excellent navigation and high average speeds.

1000 KILOMETER RENNEN, NÜRBURGRING, 1956.

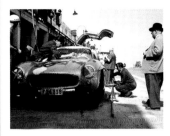

- - - - - - PLATE 25

The Mercedes 300SL gull-wing coupe was a landmark design. It first appeared at the Mille Miglia in 1952, then won the Twenty-Four Hours of Le Mans. By 1954 Mercedes had decided to produce the car in relatively large numbers for serious enthusiasts. Its design features included the famous gull wing doors and a tubular space frame carrying a body that in production form was usually steel, while a lighter aluminum body was available for competition. Mercedes campaigned the car in the early 1950s, with particular success in the long-distance road races of the day, most notably the 1952 Mexican Road Race.

1000 KILOMETER RENNEN, NÜRBURGRING, 1956.

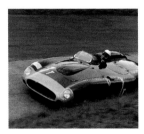

- - - - - - PLATE 26

The Ferrari 860 Monza is driven by Eugenio Castellotti, practicing for one of the most challenging sports car races on the European calendar: one thousand kilometers around the fourteen-mile "Nordschleife," a track that was built in the 1920s to relieve the heavy unemployment in Germany's Eifel region. Castellotti concentrates as he negotiates the famous "Karussel" corner, a concrete ditch two-thirds of the way around the circuit. Officially, the Nürburgring is comprised of eighty-nine left-hand bends and eighty-five right-hand. Castellotti finished second.

GRAND PRIX OF MONACO, 1956.

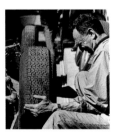

- - - - - - PLATE 27

Racing mechanics work long hours. However, they are devoted to their teams and should a victory occur their emotions run as high as those of the most ardent race fan. They often provide the most interesting and exciting race images. This Ferrari mechanic uses his strong hands to mount rear tires on a Formula One car.

GRAND PRIX OF MONACO, 1956.

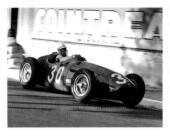

- - - - - - PLATE 28

The Maserati 250F driven by Jean Behra powerslides out of "Gazometre" or "gas works" corner. The photograph was taken during early morning practice, a wake-up call for Monte Carlo residents. Behra had raced for several years with the French team of Gordini but moved to Maserati in 1955. With the retirement of Mercedes at the end of 1955 Stirling Moss decided to join Maserati, and he had a good year in 1956. This day, Behra finished a strong third while Moss enjoyed superiority over the Ferraris of Fangio and Collins. Notice the sand bags, which provide more protection to the light pole than to car and driver, and the curb, which is very unfriendly to a sliding race car.

GRAND PRIX OF MONACO, 1956.

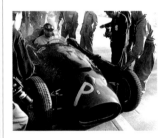

- - - - - - PLATE 29

World Champion Juan Fangio leaves the pits in the Lancia D50, which now carries a Ferrari badge. The letter "P" stands for "Prova," an indication that Fangio is trying the car before deciding if it is the one he prefers. In the race he chose to drive a modified D50, a design that lasted throughout the season. Fangio had a challenging race, finding it difficult to catch the Maseratis of Moss and Behra. But the Argentine maestro was able to finish second behind Moss after taking over the Ferrari of his English teammate Peter Collins.

MILLE MIGLIA, BRESCIA, ITALY, 1956.

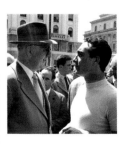

- - - - - - PLATE 30

Enzo Ferrari speaks with his driver Castellotti during scrutineering for the Mille Miglia. Castellotti was the winner of the 1956 race, driving a Ferrari (the race was held in a torrential rain and there were many accidents). The photograph is unusual because Enzo Ferrari rarely came to a race, although he would appear at practice or to a test session near the factory. In this instance the Mille Miglia was a race dear to Ferrari as he had been involved with the event from its beginning. At that time he was racing with Alfa Romeo, entering a team of Alfas as early as 1930, with the drivers Nuvolari and Guidotti winning the race in their Alfa at an average speed of 62 mph.

GRAND PRIX OF FRANCE, REIMS, 1956.

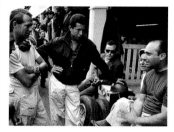

----- PLATE 31

Fangio was held in great respect by his fellow drivers. In the photograph he is chatting with three other Ferrari drivers. From left to right: Eugenio Castellotti, Peter Collins, and Olivier Gendebien.

NÜRBURGRING 1000 KILOMETERS, 1956.

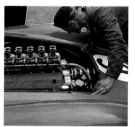

----- PLATE 32

The Ferrari mechanic inspects the twelve-cylinder engine with great care prior to the start. The 1000 Kilometers of the Nürburgring was considered to be an arduous event, where Ferrari sports cars were in their element. However, in 1956 the Ferrari of Fangio and Castellotti came in second behind the Maserati of Moss and Behra, who took over the car of Schell and Taruffi with all four accepting the victory wreath on the podium.

TWENTY-FOUR HOURS OF LE MANS, 1956.

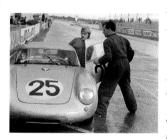

----- PLATE 33

The driver is Richard von Frankenberg, who raced for Porsche in the 1950s. He was a journalist and author who edited the Porsche magazine "Christophorous" in its early years and wrote extensively about his experiences behind the wheel of Porsche sports cars. He and Wolfgang von Trips won their class and were fifth overall at Le Mans in 1956. Both men made a major contribution to Porsche's racing successes in the 1950s. Later that year, von Frankenberg miraculously survived a horrific accident when his Porsche race car skidded over the top of the banking at Berlin's Avus track.

GRAND PRIX OF ITALY, MONZA, 1956.

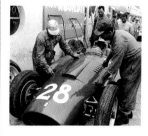

----- PLATE 34

The scene is practice and the mechanics are about to check the engine of Musso's Ferrari. Practice sessions in the 1950s and well into the 1960s were a time when one could mingle with the drivers and teams, glean information about how they were doing, and generally "hang out." Even the local priest was welcome.

NÜRBURGRING 1000 KILOMETERS, 1956.

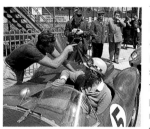

----- PLATE 35

Ferrari team drivers Phil Hill and Luigi Musso (in car) during practice. Hill, a very successful sports car driver from the USA, first came to Europe in 1952 to participate in the legendary races that held such a fascination for Americans. Le Mans, Nürburgring, and the Targa Florio were the classic events that drew serious enthusiasts and drivers. Hill became World Champion in 1961. Many observers feel that his three greatest achievements were his three Le Mans wins (1958, 1961, and 1962) and the 1958 Italian Grand Prix at Monza, where he led the entire pack for six opening laps, then spun out but was able to rejoin the race.

1000 KILOMETER RENNEN, NÜRBURGRING, 1956.

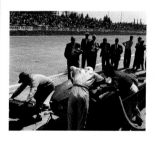

----- PLATE 36

A refuelling stop for the Moss/Behra Maserati that won the race. In his eagerness to fill the tank Moss appears to be holding two fuel hoses while his codriver Jean Behra yells something in his ear. In the background the photographers will be waved away by track marshals. With the danger of fire ever present in the pits during refueling, it was not a safe place to be. The car being refueled had started the race in the hands of Taruffi and Schell, then been given to Moss and Behra after their car broke its suspension. Fifty-seven cars started the race, and thirty-one retired.

PIERO TARUFFI, MILLE MIGLIA, BRESCIA, ITALY, 1957.

– – – – – PLATE 37

Taruffi is celebrating victory. After sixteen attempts, he finally claimed victory. His average speed was ninety-five mph, not as fast as the 1955 record set by Stirling Moss but nevertheless a resounding victory that ended an important chapter in motorsports. The Mille Miglia was finished, because of the tragic accident of Portago, which killed ten spectators as well as himself and his co-driver.

STUART LEWIS-EVANS, VANWALL, FRENCH GRAND PRIX, REIMS, 1957.

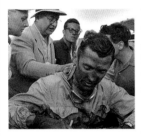

– – – – – PLATE 38

The photograph was taken at the end of the race, and Lewis-Evans is exhausted, suffering not only from the heat but from the rigors of completing a 300-mile Grand Prix on one of the fastest tracks in Europe. This was his first race with Vanwall. Notice that the windshield is covered in grime. Drivers of the day carried two sets of goggles, and Lewis-Evans always wore a girdle-like stomach brace. Tony Vanderwell (in hat), the founder and "patron" of the Vanwall team, is behind Lewis-Evans on the left and joins the Vanwall mechanics in congratulating him on finishing third after a hard fought battle with the winning Ferrari of Luigi Musso.

GERMAN GRAND PRIX, NÜRBURGRING, 1957.

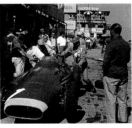

– – – – – PLATE 39

This was World Champion Juan Fangio's finest hour, and these three successive images are a glimpse into the drama of the day, August 4, 1957. Driving for Maserati, Fangio was headed for his fifth World Championship at the wheel of the Maserati 250F, which one writer had described as "that most elegant of all racing cars. It matched itself to Fangio's greatness." Fangio displayed his greatness during a mid-race pit stop and what was to follow. He was in a comfortable lead over the two Ferraris of Collins and Hawthorn when on lap eighteen he entered the pits. This meant new tires at the rear plus

more fuel. But the pit stop was bungled when one of the mechanics dropped the knock-off hub and it rolled underneath the car. As they scrabbled to find it, the two Ferraris passed through into the lead. Finally, new rubber at the rear was installed. Calm as ever, Fangio got back into the car and roared off. In the next few laps, he not only caught up and passed the two Ferraris but also set new lap records in the process as he claimed the World Championship.

GERMAN GRAND PRIX, NÜRBURGRING, 1957.

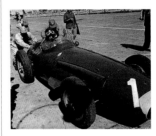

– – – – – PLATE 40

Fangio gets a push from the two Maserati mechanics as he sets off on the final laps of the race, which turned out to be his last Grand Prix victory.

GRAND PRIX OF GERMANY, NÜRBURGRING, 1957.

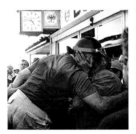

– – – – – PLATE 41

The race is over, and the Argentine champion is embraced by team manager Nello Ugolini while the photographers scramble for pictures. Fangio was forty-six at the time of this triumph, an age when most racing drivers have long since retired. According to Nigel Roebuck, writing about Fangio in the book *Grand Prix*, "In the closing laps of the race he constantly broke the lap record and in the final minutes took back the lead, winning finally by three seconds. It was his greatest victory and proved to be his last." The following year, 1958, Fangio decided to retire.

GERMAN GRAND PRIX, NÜRBURGRING, 1957.

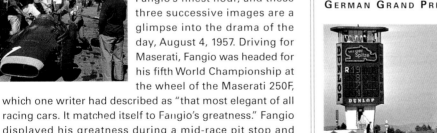

– – – – – PLATE 42

At the beginning of lap twenty Fangio is still third, but on the next lap he will overtake the two Ferraris and go on to win. When Fangio's car was taken back to the factory at Modena, it was found to be totally out of wack and in need of refurbishing.

GRAND PRIX OF SWEDEN, RABELOV, 1957.

– – – – – PLATE 43

With his mechanic close by, Ferrari driver Luigi Musso waits for permission to start a practice lap. Note that his helmet carries the national flag of Italy, his home country. Musso always wore a yellow helmet. Every driver wore polo-style helmets, a big change from a decade earlier when a simple cloth cap was preferred. The helmets of the day became battered and worn and were a distinctive part of the "look" that each driver had.

GRAN PREMIO PESCARA, 1957.

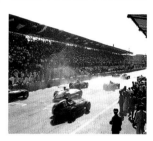

– – – – – PLATE 44

Pescara is an Italian city with a long history of motorsports. The 1957 race attracted a strong entry as it counted towards the World Championship. The view here is from the press stand at the moment of the start. In the foreground the Vanwall of Brooks is attempting to overtake Masten Gregory's Maserati. The winning Vanwall of Moss is in the middle of the front row between the Ferrari of Musso and the Maserati of Fangio. Attrition was always high in Formula One events of the day, particularly in the heat of mid-August, when Pescara scheduled the 1957 race. There were only seven finishers from a field of sixteen due to the length of the circuit, which was slightly longer than the Nürburgring.

GRAND PRIX OF ITALY, MONZA, 1957.

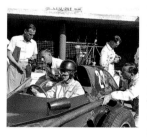

– – – – – PLATE 45

Tony Brooks's Vanwall is pushed onto the track by the "lads," an English euphemism for the hard-working mechanics who prepare the race cars. Teammate to Stirling Moss, Brooks was enrolled in dental school while driving for Connaught. In 1955 he drew the attention of the motorsports press when as a new talent he easily won the Grand Prix of Syracuse at the wheel of a Formula One Connaught. He had never driven on the continent before and had never met any of the star European drivers of the day. His services were quickly snapped up by Tony Vandervell's Vanwall team. His career reached its high point in 1958 with victories in the German, Belgian, and Italian Grand Prixs.

BRITISH GRAND PRIX, SILVERSTONE, 1957.

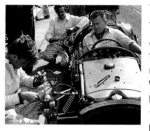

– – – – – PLATE 46

The gentleman in the cockpit is Alf Francis, mechanic to Moss for many years. They had first met at HWM in the early 1950s. When Stirling purchased a Maserati Formula One car in 1954, he asked Alf to join him. He and the three other mechanics are bleeding the brakes on the Cooper prior to practice. Francis was from Poland and served in the Polish military in England during World War II.

REIMS TWELVE HOURS, 1957.

– – – – – PLATE 47

The drivers are lined up opposite their cars ready for a dash across the road when the flag falls at midnight. A Le Mans–type start was often used for events such as this. The Reims TwelveHours for Grand Touring cars was usually held on the Grand Prix circuit the Saturday night of the Formula One race. All the usual hazards of night racing applied: fog, the possibility of rain, and a wide speed differential between faster and slower cars.

GRAND PRIX OF ITALY, MONZA, 1958.

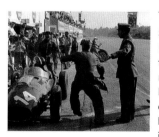

– – – – – PLATE 48

Soon-to-be World Champion Mike Hawthorn has arrived in the pits with his Ferrari at mid-race for a change of rear tires. Lead mechanic Marchetti is dashing towards him with a bottle of water in hand. Mike is shouting something to team manager Tavoni while the tire engineer (in white shirt) approaches for a temperature check. Notice the policeman officiating, while in the background mechanics are bringing out fresh tires for the eventual winner, Brooks in the Vanwall. Hawthorn finished second despite a damaged clutch.

GRAND PRIX OF MONACO, MAY 1958.

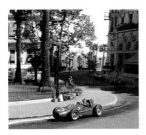

PLATE 49

Mike Hawthorn's Ferrari rounds the Casino corner. In the shadow on the right is the entrance to the Hotel de Paris; the Casino is on the left of the picture. Hawthorn led the opening laps but then retired with mechanical problems. The race was won by Maurice Trintignant driving a Cooper. Monaco is the ultimate "round the houses" circuit. This was Hawthorn's year: he won the world championship for Ferrari despite a challenge from England's Vanwall team led by Moss and Brooks. Hawthorn was tragically killed in a road accident in January of 1959.

WOLFGANG VON TRIPS, NÜRBURGRING, 1958.

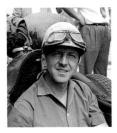

PLATE 50

The portrait of Count von Trips was taken at the Nürburgring in preparation for the German Grand Prix. Trips began his career with Porsche and had immediate success in the Mille Miglia, finishing second in 1954 and then in 1955 with a 1300 cc Porsche doing well despite transmission problems. Trips was young and had a great passion for the sport. Both Mercedes and Porsche utilized his talents. By 1956 he had signed with Ferrari and before long it became clear that he had the potential to become Germany's next World Champion. Sadly his career ended at Monza in 1961 in a tragic accident on the second lap when the Ferrari made contact with Jim Clark's Lotus. Trips crashed fatally, taking fourteen spectators with him.

MARANELLO, ITALY, SCUDERIA FERRARI RACE SHOP, 1958.

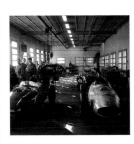

PLATE 51

Enzo Ferrari hosted an annual visit for the press to his factory, usually in mid-winter before the racing season started. This was an area of the factory that was off limits during the rest of the year. The lighting in this image accentuates the old world atmosphere of the place.

MIKE HAWTHORN, TWENTY-FOUR HOURS OF LE MANS, 1958.

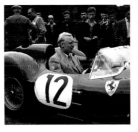

PLATE 52

The photograph was taken during scrutineering. Hawthorn is presenting the Ferrari for technical inspection several days before the race. Scrutineering at Le Mans is still held in the same place, a large park in the heart of the city. In 1955 Hawthorn was involved in an accident at Le Mans that resulted in the deaths of over seventy spectators. Contributing to the accident was the fact that the track itself was considerably narrower than it is today, and the great difference in speeds between slower and faster cars made overtaking a challenge.

TARGA FLORIO, 1958.

PLATE 53

Luigi Musso, Ferrari, 1958. Roaring past the finish line near Cerda, Luigi Musso starts another forty-four-mile lap in the oldest continously held open road race in the world. Teamed with Belgian Olivier Gendebien, Musso managed to bring the car home in first place covering the distance in ten and one-half hours at an average speed of 84 mph. Covering the race was a challenge for photographers since access to most of the course was limited. However, the Sicilian people and the rugged landscape offered incredible backdrops and journalists of the day loved the opportunity to visit Sicily and cover the Targa.

GRAND PRIX OF FRANCE, REIMS, 1958.

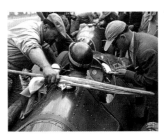

PLATE 54

Fangio is caught during practice while he talks with Guerino Bertocchi, Maserati chief mechanic. Bertocchi's son takes notes. The flag in Bertocchi's hand was used to guide the driver into the pits.

Grand Prix of France, Reims, 1958.

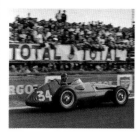

– – – – – – PLATE 55

Fangio is exiting a slow corner and looks over his shoulder to see who is behind him. The photograph captures the beautiful lines of the 250F Maserati as it accelerates away. Fangio was not happy with the car's handling, but he soldiered on to finish fourth. However, this was to be his final GP, for he retired shortly thereafter.

Grand Prix of Syracuse, Sicily, 1958.

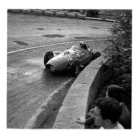

– – – – – – PLATE 56

One of the highlights of the racing calendar of the 1950s was that a number of races were held in distant but beautiful regions, one of them being Sicily, home to the Targa Florio and Syracuse, which hosted a Formula One race in the spring before the main season got under way. The circuit was on the edge of the beautiful old city. In this picture the winning Ferrari of Luigi Musso is seen in action.

Targa Florio, Sicily, 1958.

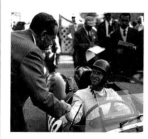

– – – – – – PLATE 57

Peter Collins, the young English Ferrari driver, finished fourth in the 1958 race, co-driving with Phil Hill at the wheel of a 250TR. First run in 1906, the forty-four-mile circuit in the Madonie mountains was the last open road race in this heroic age of motor racing. Congratulating Collins is Count Vincenzo Florio, who founded the race and was its sponsor until his death in 1959.

Grand Prix of Germany, Nürburgring, 1958.

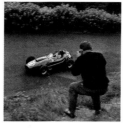

– – – – – – PLATE 58

Soon-to-be World Champion Phil Hill is in his first Grand Prix drive for Ferrari. The car is a single seater Formula Two machine, and he is seen rushing downhill through the infamous "Fuchsröhre" section of the Ring. The image is unusual for several reasons: it was taken with a Rolleiflex camera, hardly considered the best tool for action; and the action has been captured at the precise moment that the rear wheel is passing the arm of the photographer in the foreground, a totally accidental element.

Twenty-Four Hours of Le Mans, 1958.

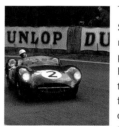

– – – – – – PLATE 59

Stirling Moss drove for Aston Martin many times during the 1950s and was part of the winning Aston team at Le Mans in 1959. This picture of Moss in the DBR1 was taken in the "esses," a fast left-right bend ideally suited for close action shots of car and driver. In 1958, when this picture was taken, mechanical failure caused his early retirement. The race was won by the Ferrari team of Phil Hill and Olivier Gendebien.

Twenty-Four Hours of Le Mans, 1958.

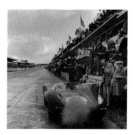

– – – – – – PLATE 60

The Hamilton/Bueb D Type Jaguar rejoins the race after a pit stop during the final hours. The deserted track illustrates how after hours of racing the cars are spread out over many miles and close racing is unusual near the finish. By then the drivers are primarily concerned with getting their cars home in one piece.

GRAND PRIX OF GERMANY, NÜRBURGRING, 1958.

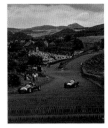

— — — — — — PLATE 61

The 1958 German Grand Prix was a bittersweet race for England. The fatal accident of Peter Collins, the popular Ferrari driver, totally overshadowed the victory of Tony Brooks's Vanwall. In this mid-race image Collins is overtaking a slower car while trying to stay ahead of his teammate, Mike Hawthorn, who soon passed him. The crash occurred in the middle of the eleventh lap when Collins failed to negotiate a 100 mph bend known as "Pflanzgarten." He was ejected from the car as it somersaulted off the road. The photograph illustrates the mountainous German landscape that was the feature of the fourteen-mile Nürburgring, a track that today is open to one and all but no longer used for Grand Prix racing.

GRAND PRIX OF FRANCE, REIMS, 1958.

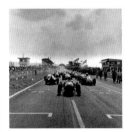

— — — — — — PLATE 62

This is a picture of a race start that would be impossible to get today. The view is up the main straight at Reims looking at the long line of pits and grandstands to the Dunlop bridge, which was set up over the track and used for entertaining VIPs by the Dunlop tire company. At the back of the starting grid the camera has captured the scene just seconds before the flag falls. Nearer the front of the grid is Phil Hill in a Maserati, his first Grand Prix drive. World Champion Juan Fangio is also there in the third row alongside Moss. It would be Fangio's last race. The poor performance of the Maserati meant a fourth-place finish. The eventual winner, Mike Hawthorn, is on the pole and at the very rear is another Englishman, Cliff Allison, in a Lotus. In the next to the last row on the right is Troy Ruttman. This particular stretch of highway connects the city of Reims with the town of Geux. The whole Reims circuit was part of the French highway system.

TARGA FLORIO, 1958.

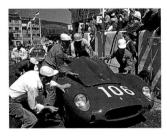

— — — — — — PLATE 63

Luigi Musso comes into the pits in the middle of the race after overshooting the pits due to a complete loss of brake fluid.

TARGA FLORIO, 1958.

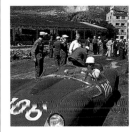

— — — — — — PLATE 64

Musso is now out of the car, and his co-driver Olivier Gendebien has taken over. The Italian/Belgian duo driving the 3-litre twelve-cylinder Ferrari handily won the race a full six minutes ahead of the second-place Porsche. Attrition again was high. Out of the forty-one starters only thirteen finished.

GRAND PRIX OF ITALY, MONZA, 1958.

— — — — — — PLATE 65

The view is of the start taken from the press stand high above the main tribune. Monza is the home of motor racing to Italians. The crowds are monumental, consisting primarily of Ferrari fans, the "Tifosi" who pray every year for a Ferrari win. In the photo the Vanwalls of Moss, Brooks, and Lewis Evans have already moved into the lead with the Ferraris in close pursuit. The race was to have determined the outcome of the 1958 World Championship between Moss (Vanwall) and Hawthorn (Ferrari). However, Hawthorn had clutch trouble from the very beginning that plagued him throughout. Moss retired early with engine problems, and the race was won by Tony Brooks in his Vanwall. Mike Hawthorn struggled home second and went on to win the Championship six weeks later at Casablanca.

TARGA FLORIO, SICILY, 1958.

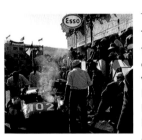

— — — — — — PLATE 66

The "Targa" as it was known was first run in 1906 and was the last of the great open road races. It was the brain child of Vincenzo Florio, a wealthy Sicilian of noble birth. Despite the fact that Sicily had no roads to speak of, Florio and his supporters were able to carve out a route which in a number of versions lasted until 1973. The final course was known as the "Piccolo Circuito delle Madonie," referring to the Madonie mountain range which the route traversed. One lap was almost forty-five miles long, and the regulations called for eight laps. Attrition was high. Here a Ferrari "Testa Rossa" is being repaired in the pits.

MODENA, ITALY, 1959.

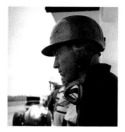

------ PLATE 67

The American driver is Richie Ginther waiting his turn at the wheel of a Ferrari Formula One car. At the beginning of his career with Ferrari in Europe, he became a talented test driver. Then, along with his friend Phil Hill, already a full member of the team, Richie drove Formula One for several years. Note the polo helmet, which was typical of the day.

GERMAN GRAND PRIX, AVUS-BERLIN, 1959.

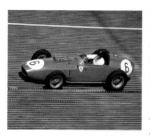

------ PLATE 68

Berlin was the home of the famous but outmoded Avus track. Its principal feature was a brick-paved high speed banking. In the photograph Dan Gurney's Ferrari is seen on the banking, which was treacherous when wet. There were several accidents, one fatal to Jean Behra when his Porsche skidded out of control, sliding up and over the top of the banking to land in the parking lot below. In the race Gurney came home second while his teammate Tony Brooks finished first.

TARGA FLORIO, SICILY, 1959.

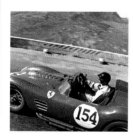

------ PLATE 69

Co-driving with Cliff Allison, Dan Gurney in a Ferrari is high in the mountains during the running of the forty-fourth Targa. The oldest motor race in the world, Sicily's Targa Florio favored smaller and lighter cars, in particular Porsche, which had great success in the narrow winding mountain roads that characterized the event.

1000 KILOMETER RENNEN, NÜRBURGRING, 1956.

------ PLATE 70

The Ferrari mechanic is holding up the signal board. One lap on the Nürburgring is well over ten minutes, and this amount of time posed a challenge to team managers. Clear signals were important each time the car came by. The message here is that sixty-four seconds separate him from the leader.

1000 KILOMETER RENNEN, NÜRBURGRING, 1959.

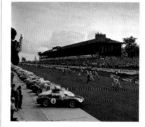

------ PLATE 71

The classic "Le Mans start" is illustrated in the following two images. The drivers run toward their cars at the drop of the flag. Moss, the third driver from the right, is already in front of many of his rivals. His eyes are focused on the Aston Martin DBR1, the fourth car parked beyond the two Ferraris and the Porsche.

1000 KILOMETER RENNEN, NÜRBURGRING, 1959.

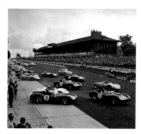

------ PLATE 72

In this image Moss has already disappeared out of the picture. Dan Gurney in Ferrari number five is slightly ahead of the Porsche number fifteen driven by Hans Herrmann. Gurney's teammate, Tony Brooks, in car three is still struggling to get the Ferrari started, while Phil Hill in number four Ferrari has begun to roll. Note the wide variety of cars (even a Thunderbird) from large displacement race cars such as the Ferraris to the smaller and more nimble Porsches. Note also the large crowd in attendance. The race again saw a victory for Stirling Moss and Jack Fairman in the Aston Martin, with the Ferrari of Phil Hill/Olivier Gendebien a close second.

GRAND PRIX OF HOLLAND, 1959.

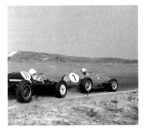

－ － － － － PLATE 73

Jean Behra's Ferrari leads Stirling Moss and his Cooper-Climax through the fast right-hand bend at the end of the long front straight. Behra was accused of blocking Moss as the Cooper was quicker and more nimble with its rear engine and lighter chassis. The photograph clearly portrays the transition from front-engine to rear-engine configurations that occurred at the end of the 1950s. Unfortunately for Moss, the gearbox failed on his car near the end of the race, and a front-engined BRM driven by Sweden's Jo Bonnier claimed a hugely popular win for BRM.

TWENTY-FOUR HOURS OF LE MANS, 1959.

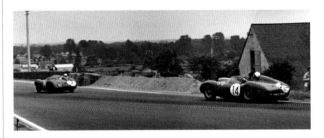

－ － － － － PLATE 74

The photograph was taken at Tertre Rouge corner, a fast bend that leads into the long Mulsanne straight. Ferrari number fourteen is driven by Phil Hill, who won the race the year before with Olivier Gendebien. Leading Hill in the corner is the Aston Martin of Graham Whitehead and Brian Naylor. The Mulsanne straight allowed speeds of over 150 mph with a race average speed of 125 mph. Today, even with chicanes to slow the cars at faster parts of the track, 200 mph-plus speeds are the norm on the straight.

1000 KILOMETER RENNEN, NÜRBURGRING, 1959.

－ － － － － PLATE 75

Sweden's Jo Bonnier takes the Porsche RSK through the Karussell. Bonnier, a wealthy sportsman, did well with Porsche and in the '59 race was teamed with von Trips. Until Ronnie Petersen, Bonnier was the only Swedish driver to really distinguish himself in a race car. He had great success with Porsche in the Targa Florio, winning in 1960 and 1963, second and third in 1961 and 1962. His only Formula One win was at the Dutch Grand Prix in 1959 with the BRM. Clearly he felt at home in the long-distance sports car races, and Porsche was where he had success. Jo Bonnier died at Le Mans in 1972 driving a Lola.

TWENTY-FOUR HOURS OF LE MANS, 1959.

－ PLATE 76

Stirling Moss in the Aston Martin DBR1 in which he was paired with Jack Fairman. They had already won the 1000 Kilometer race on the Nürburgring and thus hopes were high for Le Mans. Moss went into a strong lead but could not stay ahead of the Ferraris. Eventually he was forced to retire in the evening with mechanical problems. But victory was still to be had for Aston when the Salvadori/Shelby DBR1 managed to survive until the very end, all the factory Ferraris falling by the wayside with clutch troubles.

TWENTY-FOUR HOURS OF LE MANS, 1959.

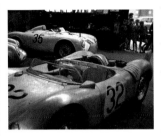

－ － － － － PLATE 77

The photograph was taken in the Ford garage at Teloché near Le Mans, which the works Porsche team always used. In the photo are three RSK Spyders, while in the doorway are village children for whom the visit by Porsche was the high point of their summer. The race cars would be driven over the road to the track and back by the mechanic or driver. It was not uncommon that the race cars would be driven to scrutineering and practice rather than taken on a trailer.

R.A.C. TOURIST TROPHY, GOODWOOD, 1959.

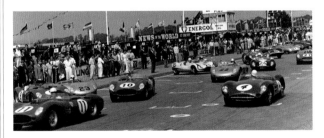

－ － － － － PLATE 78

Goodwood is considered by many to be the spiritual home of British motor racing. This famous track on the estate of Lord March has recently had a revival after being quiet for many years. This photo from 1959 shows the scene seconds after the Le Mans start. The larger and more powerful cars are pulling out onto the track while many in the back still seem to be starting their engines. Phil Hill in Ferrari number eleven is well away while the eventual winner, Moss, in Aston Martin number one is already out of the picture.

TWENTY-FOUR HOURS OF LE MANS, 1959.

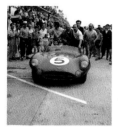

– – – – – – *PLATE 79*

This was to be Aston Martin's year in the World Sports Car Championship. Considered to be one of the most beautiful sports cars, the Aston Martin DBR1 saw victory at Le Mans, Goodwood, and the Nürburgring. With drivers Moss, Salvadori, Shelby, and Jack Fairman the Aston team led by John Wyer duelled constantly with Ferrari and Porsche. The photograph was taken at the end of the race as the winners drive towards the podium with Carroll Shelby at the wheel. Perched behind him are Roy Salvadori, David Brown (A-M chairman), and Stirling Moss. Finishing second was the Aston Martin DBR1 driven by Paul Frere and Maurice Trintignant.

DAN GURNEY, MONACO GRAND PRIX, 1960.

– – – – – – *PLATE 80*

Drivers spend a great deal of time waiting: for a mechanic to finish his work, for delays in starting, or for a teammate to come into the pits in the middle of a long race. Note that by the 1960s helmet construction had improved dramatically but drivers still used leather gloves. Fire-resistant clothing was still in development.

GERMAN GRAND PRIX, NÜRBURGRING, 1960.

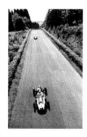

– – – – – – *PLATE 81*

World Champion Jack Brabham is on the home stretch in this non-championship race at the Nürburgring. The race was largely run in very wet conditions. This image was taken in practice but illustrates the diverse character of the Ring. This long stretch leads to the front pit straight and the start/finish line. The 1960 race was dominated by the Porsches of Bonnier and von Trips, but Brabham relentlessly held onto them to retain the World Championship.

1000 KILOMETER RENNEN, NÜRBURGRING, 1960.

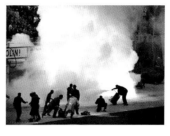

– – – *PLATES 82–86*

During a mid-race Ferrari pit stop, fuel was spilled and ignited into a tremendous fire. As Scarlatti is helped away, the Ferrari is totally engulfed and dwarfs the one fireman with his extinguisher. With the whole incident lasting minutes, only one car was destroyed, but it was an example of how ferocious a gasoline fire can be.

GRAND PRIX OF EUROPE, MONZA, 1960.

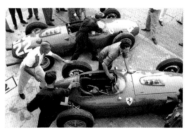

– – – – *PLATE 87*

The photograph illustrates the change from front- to rear-engined Ferraris. Car number twenty is Phil Hill's Formula One car while the rear-engined racer is the 1500cc car to be driven by von Trips. Phil Hill won the race two minutes ahead of Richie Ginther in what would be the final victory for a front-engined Ferrari Grand Prix car.

GRAND PRIX OF HOLLAND, ZANDVOORT, 1960.

– – – – – – *PLATE 88*

The picture summarizes the events of the new decade and the switch to rear engines. The winner of the 1960 Dutch GP, Sir Jack Brabham, celebrates with John Cooper, builder of the car that started it all. Historian Michael Kettlewell wrote in *The World of Speed,* "Cooper racing cars built by father and son Charles and John Cooper revolutionized post-war motor racing. Their concept of a small and light, rear-engined machine of simple, straightforward construction changed the thinking in Grand Prix racing during the late 1950s and early 1960s. They gained two World Championships to prove it." A second factor that favored the smaller cars was the new rules that called for shorter races, which meant less fuel was required as well as no tire changes.

PHIL HILL, GRAND PRIX OF ITALY, MONZA, 1960.

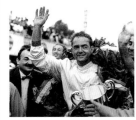

- - - - - PLATE 89

This was to be the last Grand Prix victory for a front-engined Ferrari. Decisively won by Phil Hill, the race was held on the combined road and banked circuit. Wolfgang von Trips was entered in a new rear-engined Formula Two Ferrari, but for Hill it was one of his finest hours. He would become World Champion a year later, a success that was clouded by the fatal accident of his teammate von Trips.

GERMAN GRAND PRIX, NÜRBURGRING, 1961.

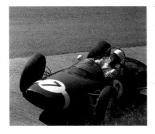

- - - - - PLATE 90

Stirling Moss is seen in the Karussell in the Rob Walker Lotus 18. Author Karl Ludvigsen described the event as follows: "Stirling put his skill to good use late that summer on a damp Nürburgring. Once again, as a lone musketeer he fought off the full might of the Ferrari team to win by a twenty second margin. That great victory on six August, 1961 was the last of the sixteen Moss victories in Championship Formula One events."

GERMAN GRAND PRIX, NÜRBURGRING, 1961.

- - - - - PLATE 91

One of the features of the fourteen-mile "Nordschleife" circuit at the Nürburgring was the many different vantage points from which to photograph. During practice for the 1961 race I took this photo at a spot where the cars lifted off the ground as they cleared the top of a place known as "Höhe Acht." My guide was the German photographer Julius Weitmann, who frequently chose to work with a large-format 4x5 Graflex camera. In this image he captures the BRM of Graham Hill in full flight.

BRITISH GRAND PRIX, AINTREE, 1961.

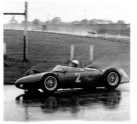

- - - - - PLATE 92

Aintree, the home of the famous Grand National horse race, was the venue for the British Grand Prix on several occasions. Liverpool was the base for the "circus," the term that was often used to characterize the Grand Prix teams and their entourage. This year saw a 1-2-3 Ferrari victory at Aintree. Here Phil Hill is seen struggling to maintain second place behind von Trips in the torrential rain that fell during the first half of the race. It was the first wet race for the new rear-engined Ferraris, and the team of von Trips, Hill, and Ginther drove the new cars brilliantly. It was Ginther's first full Formula One season.

JIM CLARK, GRAND PRIX OF BELGIUM, 1962.

- - - - - PLATE 93

The portrait of World Champion Jim Clark was taken at the end of the race which was to be his first of twenty-five Grand Prix victories. Incredibly talented, the Scot was one of the most popular drivers of the era. Richard Williams, sports writer for the "Independent on Sunday," described Clark's talent: "Nobody had taught Clark, then a twenty-three year old lowland farmer, how to do this: it was something he could do. An inbuilt sensitivity gave him the ability to drive the car beyond the normal limits of its roadholding, setting it up in what, in those days, was known as the four-wheel drift, by which the car was persuaded to take corners in long power-slides." The above quote applied to Clark behind the wheel of the big bore sports cars. In the F1 Lotus he displayed a relaxed, almost effortless style that captivated his fans. In 1968 his career came to a tragic end when he was killed in April at Hockenheim, Germany. The accident was apparently caused by tire failure.

BRITISH GRAND PRIX, SILVERSTONE, 1962.

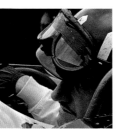

- - - - - PLATE 94

The portrait is of Graham Hill, two-time World Champion, winner of the Le Mans 24 Hours as well as the Indianapolis 500 and winner five times at the Grand Prix of Monaco. Quoting Richard Williams in his book *The Racers,* "He was the heir to Peter Collins and Mike Hawthorn, those dashing Fifties aces with supercharged libidos. Like them, and like James Hunt after them, Graham Hill was loved by the crowds because he made it all look a bit of a lark, this business of life and death. And how could a man who painted his crash helmet in the colors of his old rowing club possibly be serious?" Hill is seen in the cockpit of the BRM shortly before the start.

GRAND PRIX OF HOLLAND, ZANDVOORT, 1962.

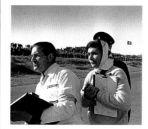

- - - - - *PLATES 95-99*

The sequence of images depicts the victory of Graham Hill driving a BRM at the Dutch Grand Prix. The track is set among the sand dunes along the coast of Holland. In the first photo Graham Hill's wife, Bette, and BRM mechanic Cyril Atkins are looking down the track as Hill completes his final lap. In the second image the mechanic stands in the middle of the track to flag him down. Graham rolls to a stop and is surrounded by Bette and others. She can now fold up her lap chart and join Graham on the podium.

GRAND PRIX OF MONACO, 1962.

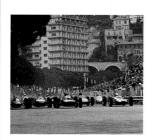

- - - - - - *PLATE 100*

At the right of the picture, the starter, Louis Chiron, is stepping over the fence seconds after he has dropped the flag and the grid begins to roll. From left to right it is Clark (Lotus), Mairesse (Ferrari), Graham Hill (BRM), Gurney (Porsche), Ireland (Lotus second row), and McLaren (Cooper). It was McLaren's day. His Cooper-Climax came in first despite the heavy opposition. The apartment buildings and homes of Monte Carlo form the backdrop. At right center is the causeway for the main railway line connecting the city with Nice to the west and Italy to the east.

GRAND PRIX OF MONACO, 1962.

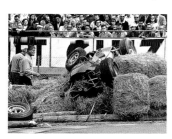

- - - - *PLATE 101*

And this is what sometimes happens a few more seconds after the start. At the end of the short straight lies a tight hairpin corner, known as Gazometre or "gas works." This Lotus got tangled up with another car, finishing its race on top of the straw bales.

GRAND PRIX OF FRANCE, ROUEN, 1962.

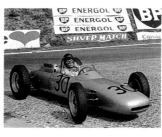

- - - - - *PLATE 102*

In the 1950s and 1960s, the French Grand Prix was occasionally held at Rouen on a beautiful circuit that was laid out west of the city. At the bottom of a long downhill fast section was a slow corner paved at its apex with traditional French cobble stones. Negotiating the cobbles is Dan Gurney's eight-cylinder Porsche, which made history that day by giving the German firm its first and only Grand Prix victory as well as Gurney's first.

TWENTY-FOUR HOURS OF LE MANS, 1962.

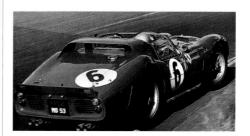

- - - - - - *PLATE 103*

The picture was taken on the inside of Tertre Rouge corner as Phil Hill in the winning Ferrari begins the entry to Mulsanne. Co-driving again with the Belgian, Olivier Gendebien, Hill drove to a resounding victory in the Ferrari 330 LM sports car. It was to be Gendebien's last race. The image was captured by standing on the earthen bank next to the track and panning with the camera.

COLIN CHAPMAN AND JIM CLARK, GRAND PRIX OF BELGIUM, 1962.

- - - - - - *PLATE 104*

Jim Clark's Grand Prix career was tied to Colin Chapman and Lotus for eight years. Friend and biographer Graham Gauld wrote of the relationship: "The rapport between Clark and Colin Chapman was legendary. His ability to tell Chapman about the handling of a car was an important factor in their success as a team." The shock of Jim Clark's death in 1968 was felt throughout the entire world of motorsports, and it is fair to say that it brought an end to a long and successful chapter in the history of these two star personalities.

JIM CLARK, WORLD CHAMPION, EARLY 1960S.

– – – – – PLATE 105

Clark was a nail-biter. The World Champion from Scotland was simply a human being. With the stress and excitement at the height of his racing career, it was no wonder that his nails were forever bitten down to the quick.

STIRLING MOSS, GOODWOOD EASTER MEETING, 1962.

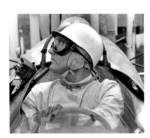

– – – – – PLATE 106

Just before going out onto the starting grid in the Lotus Climax V8, Moss waits patiently. This was to be his last race. After a number of pit stops, he crashed heavily. Serious head injuries put him in a coma for many weeks. When he finally came out of the hospital, it seemed that not only his vision but his superb sense of timing had been forever damaged. Although it was the end of his formal racing career, he began a new chapter giving demonstrations and participating in historic events all over the world. His services are sought after in particular by Mercedes-Benz, who put him behind the wheel of their historic race cars such as the famous 300SLR and W196 Grand Prix car.

INNES IRELAND, GOODWOOD EASTER MEETING, 1962.

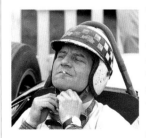

– – – – – PLATE 107

The scene is the paddock at Goodwood before the main race of the day as the drivers prepare themselves for moving onto the starting grid. Ireland is having a final smoke in the cockpit of the Lotus. Note his dirt- and grease-smeared helmet, in contrast to the helmets of contemporary drivers that are polished and gleaming with individual designs and paint schemes. Ireland's career with Lotus was set back considerably when Colin Chapman replaced him with Jim Clark in 1962, despite the fact that Innes had given Lotus their first Formula One victory at Goodwood in 1960. Ireland had had a number of victories in 1961, culminating in a win at the United States Grand Prix at Watkins Glen.

FERRARI MECHANICS, GRAND PRIX OF MONACO, MID-1960S.

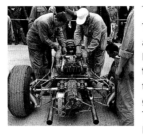

– – – – – PLATE 108

The Ferrari mechanics crowd around the latest rear-engined Formula One car and its complex twelve-cylinder engine. The spectators are held back by the rope to give the mechanics elbow room. Thirty years later, spectators at a Formula One race would never be allowed access to the pits let alone get this close to a race car being prepared in the paddock. And contemporary Grand Prix team mechanics are impeccably turned out in spotless fire-resistant uniforms.

GRAND PRIX OF MONACO, MID-1960S.

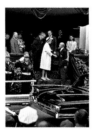

– – – – – PLATE 109

The view is of the royal box at the Grand Prix. Louis Chiron, the driver and later Clerk of the Course at the race, greets Princess Grace. Standing behind her is her husband, Prince Rainier, and directly behind Grace is Prince Bernhard of the Netherlands, who was often seen behind the wheel of a Ferrari and was known to have a passion for motorsports.

GRAND PRIX OF MONACO, 1966.

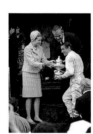

– – – – – PLATE 110

A glimpse into the future reveals Jackie Stewart accepting the winner's trophy from Princess Grace and Prince Rainier, in another popular win for BRM.

PALERMO HARBOR, SICILY, 1958.

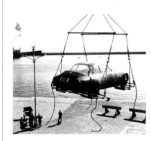

– – – – – – PLATE 111

A Targa Florio–bound Zagato-bodied Lancia is being unloaded from the Naples ferry. On the dock a Ferrari has already been unloaded. Headquarters for the Targa was in Cefalu, a coastal city approximately an hour's drive from Palermo.

JIM CLARK, GRAND PRIX OF BELGIUM, 1963, SPA / FRANCORCHAMPS.

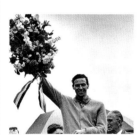

– – – – – – PLATE 112

Victory again in the Lotus 25 for Scotland's Jim Clark. Wearing his usual comfortable cardigan sweater, he accepts the crowd's applause from the podium following a gruelling race in the rain.

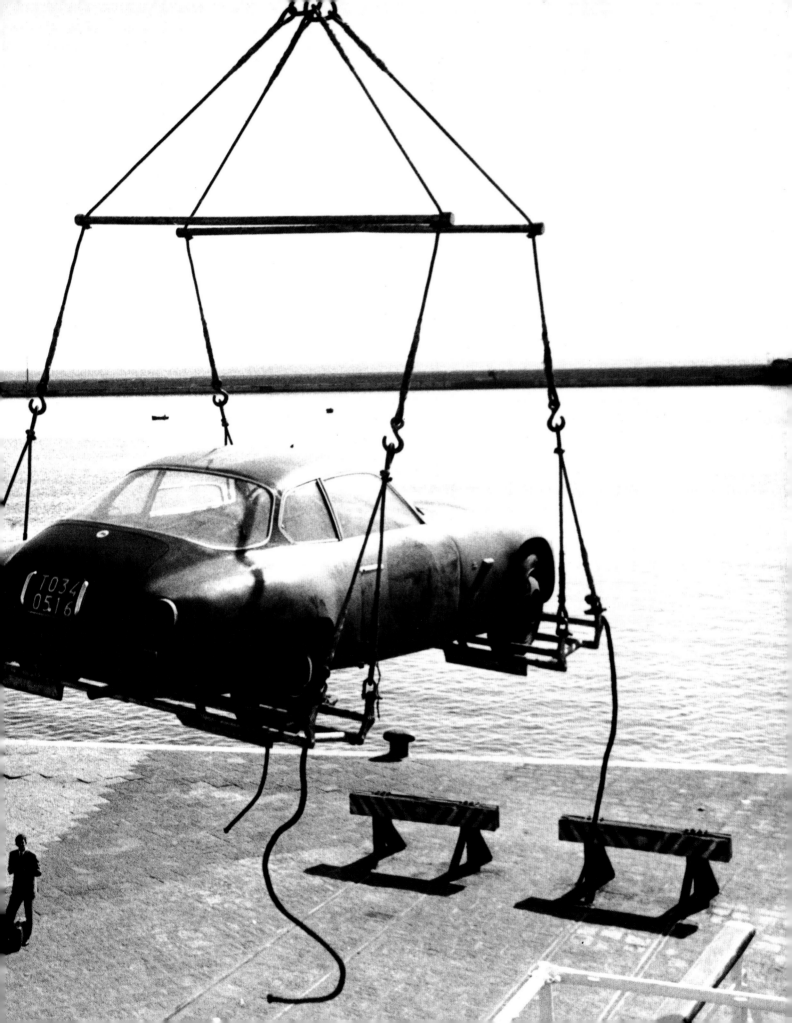

PHOTOGRAPHER'S NOTE

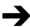

I would like to thank Stirling Moss for his fine introduction, my wife Nancy for her assistance in proofing the captions, Paul Prince and James Sly for their special contributions to *Driven,* and most of all my friend Jim Sitz who checked the captions for their accuracy. Jim "keeps us honest" as he likes to say, and I am grateful to him for his important contribution. Thanks also to historian Doug Nye, Sarah Malarkey at Chronicle Books, and my agent Wendy Brouws, all of whom helped make this book happen.

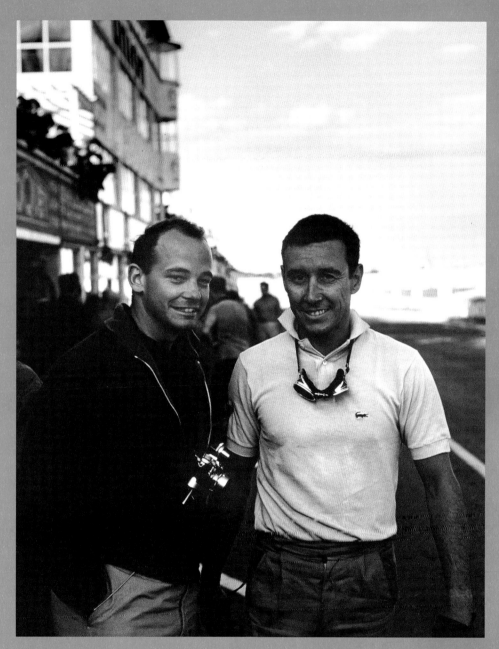

photograph by: Denise McCluggage

JULY, 1957, REIMS, FRANCE. THE AUTHOR WITH
HERBERT MACKAY "MAC" FRAZER.

Mac was an American driver in his first season of European
road racing. Tragically, he was killed the weekend the photo
was taken when the Lotus sports car he was driving crashed.

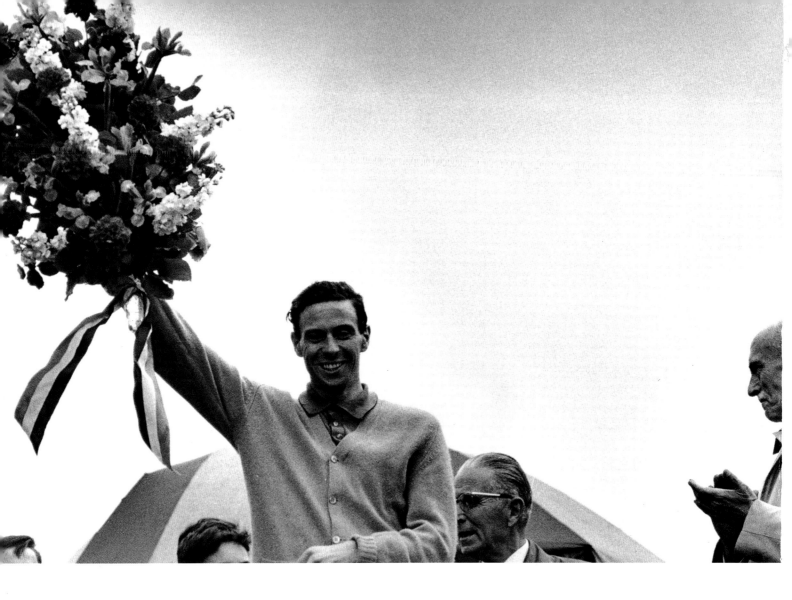

PLATE **112**